Changing Perspectives in the
Anthropology of Art

Changing Perspectives

in the

Anthropology of Art

Valda Blundell

The Golden Dog Press

Ottawa – Canada – 2000

ISBN 0-919614-88-4

Canadian Cataloguing in Publication Data

Blundell, Valda, 1941–
 Changing perspectives in the anthropology of art

Includes index.

ISBN 0-919614-88-4

 1. Art and anthropology. 2. Art and society. I. Title.

N72.A56B58 2000 701'03 C00-900060-7

Cover design by The Gordon Creative Group of Ottawa, based on art by Simon Brascoupé.

Typesetting by Carleton Production Centre of Nepean.

Printed in Canada.

Published by:
 The Golden Dog Press is an imprint of Haymax Inc.,
 P.O. Box 393, Kemptville, Ont., K0G 1J0 Canada

The Golden Dog Press wishes to express its appreciation to the Canada Council and the Ontario Arts Council for current and past support of its publishing programme.

Table of Contents

About the Cover

The cover illustration was prepared by Simon Brascoupé. Born in 1948, Simon is a member of the River Desert First Nation, Maniwaki, Quebec. He is of Algonquin and Mohawk descent (Bear Clan). Simon has sketched and painted from an early age. He learned many of the traditions and stories reflected in his art from his maternal grandmother. His originals and prints on canvas and paper are made by a stencil (*pochoir*) technique. Using this method, which goes back for many generations, inks are applied through "cut-out" stencils. Not only can the stencil technique achieve complex images, but it also allows the artist creative room to vary images slightly or dramatically from one print to another.

Simon Brascoupé's art has been exhibited in Canada, the United States, Europe, China and Cuba. His work is in major corporate and private collections. He is represented in the collections of the Smithsonian Institute, Washington, D.C., and the Canadian Museum of Civilization in Ottawa.

The cover illustrates the Tree of Life and the Four Directions in Aboriginal cultures of Canada's central (Woodland) area, including the cultures of the Mohawk and the Iroquois. The Tree of Life is a central theme of creation. It represents wisdom: in seeking wisdom of life, the Sky Woman examined the roots of the Tree and unlocked the door between the Spirit and this world. The Tree of Life also represents equality; in Aboriginal cultures, people and all of creation are equal parts.

The Four Directions are sacred to Aboriginal peoples. They can symbolize the four winds, animal spirits, and human diversity. The intersection of the Four Directions symbolizes the need for harmony in the world and the sacred relationship that binds the people of the world.

Introduction

The purpose of this book is to consider recent theoretical developments in the study of art. My focus is the study of art by anthropologists and other social scientists, in contrast to its evaluation by connoisseur – critics. I am concerned with how, as anthropologists, we can understand the role that aesthetic cultural forms play in social life. For example, how are we to define "art," and which of the many theoretical perspectives now available to social scientists are most useful for its analysis?

As I hope to show in the following chapters, the anthropological study of art has undergone significant changes since the discipline first emerged in the mid-19th century. Early concepts and theories have been altered or replaced by more recent ones, and changes in the world itself have brought about new ways of doing anthropology.

In particular, the past few decades have seen challenges to some of anthropology's most characteristic features. These features have included the identification of discrete non-Western Cultures as anthropology's focus of study, anthropology's predominant reliance on functional theories to interpret non-Western ways of life, and anthropology's belief that its accounts of other peoples represent them in an objective, value-free way.

These challenges have led many anthropologists to rethink both the goals and the theoretical tools of their discipline. This argument that anthropology is in need of "reinvention" was first advanced in 1969 in an important collection entitled *Reinventing Anthropology* edited by Dell Hymes. By the 1980s, additional publications calling for changes in the discipline had appeared, including Johannes Fabian's now seminal *Time and the Other: How Anthropology Makes Its Object*, published in 1983, and the

equally influential collection entitled *Writing Culture* edited by James Clifford and George Marcus, published in 1986 (see also Marcus and Fischer 1986 and Clifford 1988). A clearly written summary of the challenges posed by these and other anthropological writings of this period is provided by Sass (1986).

As anthropologists have reassessed their disciplinary practices, many have been influenced by broader intellectual developments of the past several decades which challenge the epistemological and ethical foundations of Western social sciences. One result of these developments has been the emergence of the interdisciplinary field of cultural studies, a field that has both influenced and been influenced by anthropological approaches (see Blundell et al. 1993). Developments in the study of symbols and signs, including those in the field of semiotics, have also had a significant impact on anthropology and cultural studies.

In the chapters that follow, my goal is to summarize recent changes in anthropology that have implications for the study of art. A related goal is to outline how new perspectives in semiotics and cultural studies have special relevance for the study of art. The literature on these developments is now enormous. Furthermore, as is often remarked, the arguments presented in this literature are frequently complex, if not dense. Readers who wish to pursue further the arguments I outline are encouraged to consult the sources listed in the Bibliography to this book.

Much of the material presented in the following chapters is derived from lectures prepared for a course I teach at Carleton University entitled "The Anthropology of Art." My lectures for this course were subsequently made available to students as a text entitled *New Directions in the Anthropological Study of Art* (Blundell 1992). The present volume is a revised and expanded version of this earlier text. Chapter 6 also draws on materials previously published in the journal *Australian-Canadian Studies* (Blundell 1989a).

In pursuing my interest in the anthropology of art, I have benefitted from my discussions with my students at Carleton and advice from colleagues, Indigenous artists, and cultural workers. I am particularly grateful to John Harp who has been a constant

Introduction

source of support in my efforts to engage with the literature in cultural studies. Special thanks to Simon Brascoupé not only for his guidance and encouragement over the years but also for providing the art for the book's cover. Special thanks as well to Marybelle Mitchell and others at the Inuit Art Foundation from whom I have learned so much. Thank you to Anthony Paz Blundell, and Randall and Christine Morlan who helped in the preparation of this manuscript for publication. Christina Thiele of the Carleton Production Centre provided invaluable editorial assistance. Finally, I am very grateful to Carleton University and to the Social Sciences and Humanities Research Council for research support over the past two decades which has permitted me to pursue my interests in anthropology, art and the Aboriginal Cultures of Canada.

Valda Blundell
Ottawa, January, 2000

Changing Perspectives

Chapter 1

Art and the Anthropological Enterprise

Before turning to new directions in the anthropological study of art, it will be useful to review the ways in which many anthropologists in the past have gone about studying objects and activities that they consider to be art. When anthropologists observe and analyze art forms, they do so in terms of the prevailing theoretical perspectives, methods, and concepts of their discipline. Therefore, I begin this chapter by outlining, albeit briefly, some of the theories, methods, and key concepts that have characterized anthropology since it emerged in the West in the late 19th and early 20th centuries. I then suggest how this general orientation in the discipline has influenced the ways in which anthropologists have studied art.

The overview offered in this chapter is intended to situate the anthropological study of art within its disciplinary context so that we can understand how anthropological approaches to art generally differ from those of, for example, sociologists, art historians, or connoisseur–critics. This overview will also provide a basis for discussions in later chapters of critiques of some of the ways that anthropology has gone about studying art. Finally, it will provide a basis for discussions in later chapters of some of the alternative approaches to art that have been influenced by new theoretical perspectives, particularly perspectives that have emerged in the inter-disciplinary field of cultural studies. There are, to be sure, differences in how anthropologists carry out their research, and in offering this general overview I am aware that I run the risk of minimizing such differences. Readers are there-

fore encouraged to consult the sources indicated as references for this chapter for a more detailed discussion of these topics.

Characteristics of Anthropology

The Holistic Nature of Anthropology

Anthropology is often described as the holistic study of humankind. What this means is that anthropology is a highly eclectic discipline, one that is interested in a wide range of topics regarding human beings, including their behavior, their belief systems, and the material objects that they make. Anthropologists ask why people think and behave as they do, and why there are changes in their behaviors and beliefs over time. They ask what traits vary most from one group to another and what traits are widely shared.

Anthropology's broad focus includes both the biological and the behavioral characteristics of humans; indeed one area of anthropological research considers how biological and behavioral traits affect one another. Some anthropologists study non-human animals in order to ask questions about how humans differ from other animals and how they may be similar. For example, some anthropologists (who are also called **primatologists**) study our closest living relatives, the non-human primates. Two such well-known anthropologists are Jane Goodall, who has studied African chimpanzees, and the late Diane Fossey, who studied African gorillas.

While anthropology as a discipline is eclectic, taking many views at one time, it is also synthetic, in that it focuses its views back on humans, and also attempts to understand how the various traits of any way of life affect and are affected by one another.

Anthropology's Broad Temporal Focus

A second, and related, characteristic of anthropology is that it does not place temporal limits on its subject matter. Using the techniques of **archaeology**, anthropology tries to understand the

6

nature of human life in the past, including how various ways of living came into being and how they have changed over time. Within anthropology, **archaeologists** (also called **prehistorians** or **palaeo-anthropologists**) are particularly concerned with how humans evolved biologically from earlier kinds of animals to their modern physical form, and how they developed various cultural forms, including tools as well as economic, social, political, and religious institutions.

Anthropology's Broad Geographical Focus

Nor does anthropology place geographical limits on its subject matter. Indeed, one of the fundamental claims of anthropology is that any statement about the nature of humankind, as for example an assertion that a particular social institution or type of behavior is "typical" of humans, must be based on data from many societies. In actual fact, much of anthropology's attention has been directed towards non-Western peoples, who live (or lived) in small societies with social and political arrangements that have been quite different from those in the so-called state societies of the West.

Three reasons have been offered for this emphasis of anthropology on non-Western societies. Firstly, it is argued that it is easier to observe the totality of a people's way of life in smaller, non-Western societies, particularly among people who base their economies on hunting and gathering or horticulture.

Secondly, as has already been noted, most anthropologists argue that a focus on many societies, including those quite different from contemporary societies in the West, brings together a more representative set of findings that permits generalization about what is typical and what is exceptional for human groups.

The third reason given for studying non-Western peoples has to do with the history of the discipline of anthropology, a topic that will be considered as it pertains to the study of art in Chapter 2. As I will elaborate there, anthropology as a recognized field of study or academic discipline crystallized during the 19th century in Western nation-states. As the discipline of anthro-

pology differentiated itself from other emerging academic fields of study, it identified as its distinctive focus, or object of study, non-Western societies that were just becoming known to Western explorers and early colonists. Importantly, these societies were located in places that were geographically remote from Europe.

Because of the influence of evolutionary theory on the emerging discipline of anthropology, many of these distant peoples were presumed to be living a way of life that had passed out of existence in the West (and was known only through archaeological studies). Such peoples were labeled "savage" or "primitive" in contrast to people in Western societies who were thought of — by Westerners — as "civilized." Because of this way of thinking, early anthropologists thought that by studying people living in geographically distant societies they could, in effect, gain insights about the way of life of their own Western ancestors.

This way of thinking about non-Western peoples is now discredited in contemporary anthropology, although, as I will argue in Chapter 6, it has had a lingering effect in the discipline because of the continued (mis)use in the "language" of anthropology of terms such as "primitive," "preliterate," "tribal," and "traditional" to refer both to ways of life and to aesthetic cultural forms.

Anthropology's Comparative Perspective

Related to anthropology's broad geographical focus is its commitment to a comparative perspective and therefore its reliance on **cross-cultural methods** of obtaining and analyzing its findings. As I have already noted, anthropologists argue that conclusions based on studies of one society cannot be taken as evidence of "human nature." Therefore, anthropologists argue that they need information from many societies in order to make generalizations about humankind.

When they observe a specific practice among a given group, for example, anthropologists ask whether that practice is in some way similar to practices found in other societies. Often they conclude that in fact this is the case, that is, that a particular practice is one instance of a more general class of behavior or that a spe-

cific social institution is an example of a more widely found type of institution.

Consider, for example, baptisms, weddings, and funerals in contemporary Euro-Canadian society. Similar types of rituals are found in many other societies and therefore they are considered examples of a broad category, referred to as **rites of passage**, whereby individuals make a transition from one status to another (for example, from being unmarried to being married in the case of a wedding).

For the discipline of anthropology as a whole, the goal is to arrive at understandings of humankind, including the identification of forms of belief and behavior that are widespread and perhaps universal. These understandings are sometimes referred to as **etic**, or cross-cultural understandings. Indeed, some anthropologists have asked whether there are "laws" that govern human behavior in the same sense that the natural sciences have claimed there are "laws" that govern phenomena in the physical world.

Participant Observation

But how, precisely, does the anthropologist obtain information about any given group of people? Since the early 20th century, the discipline's answer to this question has been to undertake a method of fieldwork generally referred to as **participant observation**. This is a strategy whereby the anthropologist spends an extended period of time living in a society different from his or her own. The anthropologist learns the language of these people, records his or her observations of their behaviors, and engages them in informal conversations about their way of life.

This method of fieldwork is called participant observation because the anthropologist not only talks to people and observes their behavior, but also participates in their day to day life (to varying degrees to be sure) and in this way attempts to understand the sources and consequences of their actions and the meanings that they ascribe to the world.

What results is an account, usually a written one called an **ethnography**, whereby the anthropologist attempts to describe —

that is, to **represent** — what a particular society is like for the people who live in it, including how their own understandings affect their actions (and vice versa) and what the consequences of such understandings and behaviors are for people in that society, in other societies, and for the natural world. This "inside" view of another way of living is often referred to by anthropologists as an **emic** view in contrast to the etic view that has been discussed above.

Cultural Relativism and Ethnocentrism

In their individual practices as field workers and in their collective efforts to bring together information about many human societies, anthropologists try to adopt a stance called **cultural relativism**. What this means is that anthropologists try to understand the beliefs and behavior of other peoples within the contexts in which they occur. The anthropologist tries to determine what such behaviors mean to the people who engage in them, what the consequences of such behaviors are in their lives, rather than what such behaviors might mean in another setting, or how such behaviors would be evaluated according to the norms of another group.

The critical argument here is that in the past most anthropologists have been from the West, but most have studied non-Western groups. Furthermore, more often than not the anthropologist has been male and from a privileged class. Were such anthropologists to interpret the behaviors and beliefs of others in terms of their own understandings of the world, they would represent not the other, but a reflected version of their own way of life. When people, including anthropologists, evaluate the beliefs and practices of other people in terms of the values and norms of their own society, they are said to be **ethnocentric**.

Advocating cultural relativism can raise ethical dilemmas for the anthropologist, who may find the behaviors or beliefs of other peoples disagreeable and in conflict with his or her own. Nonetheless, many anthropologists would argue for a stance of cultural relativism not because they consider it necessary to

10

morally sanction all human practices, but because it allows them to understand the conditions that bring about and perpetuate such practices. Even when anthropological analysis is used as part of an "applied" program to initiate change in another society, it can be argued that a necessary point of departure is an understanding of the meanings and consequences of local forms to the local people themselves.

A stance of cultural relativism also suggests that anthropology is an apolitical enterprise, which can describe (represent) another way of life in an objective way. As I will consider in Chapters 4, 5 and 6, one of the most provocative of the current critiques of anthropology has to do with such claims to total objectivity. For many anthropologists today, no representation of another way of life can ever be entirely objective, in part because of the nature of language itself. Therefore, many argue that anthropologists must take into account the particular biases that can affect their research.

The Concept of Culture

The anthropological enterprise is informed by a number of key theoretical concepts, among which the concept of **Culture** is by far the most significant. But while "Culture" is a key concept in anthropological analysis, it is a concept that is used in a number of different, albeit interrelated, ways (see, for example, Vivelo 1978).

Culture as a Way of Life

"Culture," as an anthropological concept, is part of a set of two important terms, "Culture" and "Nature." Nature comprises the material basis for human existence, but humans sustain themselves in the natural world by means of their beliefs and behaviors (including the production and use of tools) which make up their Culture. (As I will explain shortly, when referring to a way of life, I capitalize the term *Culture.*)

11

Changing Perspectives

Indeed, the importance of the "Culture" concept in anthropology reflects the discipline's belief that humans are distinct from other animals because they have Culture, and, furthermore, that it is by means of Culture that humans are able to survive in the natural world. Unlike Nature (which is a given, so to speak, to each human group), Culture is a production, or a construction, of human beings, who have a degree of understanding of their role in, and control over, this process.

That is, humans are capable of **reflexive thought**. And, importantly, the capacity of humans to both construct, learn, and reflect on a Culture is biologically based, although the specific content of a group's Culture is learned, by being born into a particular Culture but also through processes such as adoption or migration. This process by which an individual learns a particular Culture is often called **enculturation** in anthropology (or **socialization** in the discipline of sociology).

In anthropological writings, then, the term "Culture" is often used to refer to the way of life that characterizes a particular group, including the ideas and behaviors that its members share, as well as the objects, or **material culture**, that they produce. The ways of life of smaller groups within heterogeneous/pluralistic states are, by analogy, often referred to as **sub-cultures**.

Given that different groups have different ways of life, the term "Culture" is also commonly used as a noun to denote a particular group with its own distinctive way of life, and distinguish it from another such group, as for example, Cree Culture vs. Haida Culture, Canadian vs. American Culture, or "Punk" (sub)Culture vs. "Preppie" (sub)Culture. Use of the term "Culture" also contrasts with the term "**society**," in that the term "Culture" refers to a way of believing and behaving shared by individuals, while the term "society" is generally used to refer to an actual group of people who share a particular way of life. Alternatively, the term "society" is often used to refer to pluralistic, or "multi-cultural," nation states which are composed of groups with beliefs and practices that, to varying degrees, differ from one another.

12

1 — The Anthropological Enterprise

There is another point to be made here regarding the concept of "Culture" as a way of life. Although it is a view that is now being reassessed (See Chapter 4), many anthropologists have considered each Culture to have a kind of unity, by which they mean that the specific ideas, practices, and institutions in a given Culture are not randomly associated. Instead, they have been thought to co-occur according to a cultural logic. Indeed, it is just this "cultural logic" that many anthropologists have tried to describe. To argue that Cultures have a unity is to argue that practices in one area of life — say economic activities — will affect what happens in another area — say religious life — and, furthermore, that changes in one area will result in changes in the other(s).

Related to the view of Culture as a system of inter-related elements is a strong tendency in anthropology to emphasize the adaptive role of Culture in human survival. That is to say, Culture (as a way of life) is often analyzed in terms of how (and how well) it allows a society to make a living in the natural world (cf. Vivelo 1978:16).

If Culture is a way of life studied by anthropology, then the discipline as a whole attempts to document the many diverse Cultures that different peoples have constructed. Furthermore, not only is the content of each human Culture distinct, but it is subject to change. Thus the anthropological interest in documenting the diverse Cultures that humans have had throughout the world at different periods of time extends to a concern with questions regarding why Cultures undergo change.

Such studies of processes of cultural change are two-sided. Anthropologists ask how a particular cultural form is passed on, more or less unchanged, from one generation to the next. They ask why it is that children tend to act as do their parents; how, for example, is a particular way of making art transmitted from one artist to another? But anthropologists also ask questions about cultural change. Why do the members of some generations come to think and live differently than their parents, and why do new ways of producing cultural forms, including art, come about?

Culture as Aesthetic, Expressive Forms

This discussion of the concept of "Culture" as a "way of life" raises an important methodological question in anthropology. If the concept of "Culture," as I have described it, allows us to differentiate humans from the natural world and also allows us to differentiate one group from another, then how are we to make distinctions among various culturally-constructed practices and beliefs *within* a given group, that is, within a Culture or a sub-culture?

What is required are categories that allow us to consider the various elements, or components, of a particular way of life. Examples of categories commonly encountered in anthropological writing are "the economy," or "political life," or "religious life," etc. The term "culture" also appears in typologies of such elements within a given way of life. That is to say, as well as being used to refer to a group's way of life, the term "culture" is also used in anthropology in a more restricted way to refer to a category of activities or productions that can be contrasted with those labeled "economic," "political," or "religious," etc. This use of the term "culture" derives from the recognition by anthropologists that people create forms which are particularly effective for expressing their ideas about the world, and in the process, for evoking emotions such as pleasure or awe.

Anthropologists often argue that such expressive forms are found in all societies: indeed that they are is one of the major findings of comparative anthropology. Such cultural forms include myths, music, dance, and a wide range of productions with pleasing visual imagery. Sometimes called "expressive," "symbolic," or "aesthetic" forms, or — by analogy to a Western category — "art," they are broadly comparable to forms subsumed under the term "culture" in the everyday language of the West.

It is this interest in culture as aesthetic, expressive production that constitutes my primary focus in this book. Therefore, when I am referring to a way of life that characterizes a particular society, or group within society, I will capitalize the term "**Culture**," and when I am referring to forms that express an

14

individual's or a group's ideas about the world in a way that is intended to evoke (or provoke) an emotional response, I will use the term "**culture**," with a lower-case "c". I will also be using the terms "culture," "cultural forms," "art," "aesthetic forms," and "expressive forms" more or less interchangeably.

The Anthropological Study of Art

As I have indicated in this chapter, the methodological and conceptual tools of anthropology are not unproblematic, nor would all anthropologists agree with the ways that I have described them here. Indeed, as I will consider in later chapters (especially Chapters 4, 5 and 6), there are important challenges to these tools from within the discipline itself. Generally speaking, however, I believe that there are three ways in which many (and I suspect most) anthropological studies of art can be described.

Art as Part of Culture

The first point to be made, and one that allows us to distinguish anthropological studies of art from those of Western art connoisseur-critics and some art historians, is that anthropologists invariably view aesthetic forms within the broader context of the Culture in which they are found. Art is seen as part of the fabric of everyday life.

Considered within its context of production and use, anthropologists therefore ask questions about how art is related to other segments of the Culture, for example how the available technology affects the kinds of artistic forms that are made, or questions about the economic or political consequences of aesthetic activities. This is a perspective that differs from the widely held view in the West that art and art-making are distinct and separate from other areas of social life, or that art is the result of individual genius and inspiration. Anthropologists rarely ask whether a work of art is "good," but rather they ask what role it plays for a particular group.

15

Anthropologists generally focus not only on the work of art itself but also on its production and use in the society where it is found. Anthropologists also tend to emphasize what is typical rather than what is unique. Art is viewed within the context of a **tradition**, that is, a set of conventions for its production and use, and the members of a particular society are seen as sharing these conventions as well as having culturally specific and shared ideas about what constitutes a pleasing aesthetic form.

The Bio-Genetic Basis of Art

As noted above, anthropologists are interested in how human biology and behavior are interrelated. Therefore, some anthropologists ask questions regarding the biological basis of art, an interest that they share with some psychologists (see, for example, Alland 1977).

One of the most debated questions about art, and a question also asked by philosophers, is whether there is such a thing among humans as a distinctive aesthetic response. If so, it is asked whether this response is brain-based (cognitive) in nature. And if so, it is also asked whether this response is uniquely human or whether it can be identified, at least to some degree, among our closest living relatives such as the chimpanzees. Is beauty merely in the eye of the beholder, culturally defined in an endless array of ways, or is it possible to delimit the range of forms that will, or will not, evoke an aesthetic response?

Anthropology's interest in biology, as well as the prehistoric past, also means that some researchers ask how aesthetic practices first came into being among humans or human ancestors, and what these first forms of human art were like.

Defining "Art" Cross-Culturally

Finally, anthropology's commitment to a cross-cultural perspective leads to an interest in the production and use of aesthetic forms in all societies, including those that can be "recovered" or "reconstructed" only through the techniques of archaeology. Thus any definition of art used by an anthropologist must be ap-

plicable cross-culturally, and identifications of art forms as well as assessments of their qualities must not derive from the imposition of Western (or any other culturally specific) aesthetic norms.

That is to say, anthropologists do not take as given ideas in the West as to what constitutes an art form. As a result of studying many societies, including many that are very different from those in the West, anthropologists have concluded that Western ideas about what constitutes "art" are at best culturally specific and, at worst, an extension of efforts on the part of the West to impose their own views on culturally different others.

Anthropologists therefore generally have a much broader definition of "art" than is usually the case in the West, especially definitions promoted by art connoisseurs and critics. Anthropologists have observed that in many societies pleasing aesthetic forms are used in everyday life as components of important rituals and ceremonies. This contrasts with the view now prevalent in the West that "art" is something found separated in art galleries or in other designated settings such as theaters, museums, or festivals.

For anthropologists, art forms do not include just paintings, music, dance, architecture, and written "literary" forms. Art also includes forms as diverse as myths, miming, body decorating, clothing, feather work, and a vast range of decorated utilitarian objects that are often relegated in the West to the status of "crafts."

As I will consider further in Chapter 4, this broader view in anthropology of what constitutes aesthetic production has influenced recent critiques of cultural theory that are being made in the West, in particular critiques originating in the interdisciplinary field of cultural studies. Anthropology's broader definition of art also means that anthropological analyses of popular expressive forms produced in the West (so-called **popular culture**) can be undertaken.

Summary

In this chapter, I have suggested that there are widely shared ideas among anthropologists about the methods and key concepts of their discipline, and that these research tools lead them to study art in a distinctively anthropological way. Importantly, for anthropologists, the making and use of art never occurs in a vacuum but within a wider cultural context where art both influences and is influenced by other aspects of Culture (as a way of life). Anthropologists argue that we must always view (or listen to, or feel, or taste) art within this broader context. Art must also be related to the technological, economic, and political aspects of a group's way of life. And, finally, art must be defined cross-culturally, not solely in the terms of the West.

Chapter 2

Anthropology's Changing Interest in Art

Before turning to recent developments in the anthropological study of art, I want to consider how anthropology first became interested in aesthetic cultural forms. Significantly, as we shall consider shortly, early anthropologists did not direct their attention to art. To understand why this was the case, and how anthropologists subsequently became interested in art, it is necessary to take into account the historical context within which anthropology first emerged. In particular, it is necessary to understand that this early context included, firstly, the identification of remote non-Western others as the special focus of anthropological analysis, and, secondly, the popular belief at this time, and one shared by early anthropologists, that such peoples were not capable of making art.

The context in which anthropology matured as an academic discipline was, however, a changing one. Thus the early belief that the remote non-Western peoples studied by anthropologists did not produce art was overturned. The new recognition of art-making among these peoples was the result of new ways of thinking about art which originated among Western artists in the early 20th century and influenced anthropology.

The early 20th century also saw methodological and theoretical changes in anthropology which made possible the recognition and the study of the art of other peoples. In particular, these changes involved the development of anthropology's characteristic method of participant observation and the associated call for anthropologists to adopt a position of cultural relativism.

These changes also led to the general replacement of anthropology's earlier concern with the evolution of cultural forms by a functional perspective.

Early Views in the West

Let us begin by considering how the objects of non-Western peoples, now widely considered to be art forms, were thought about in the West as anthropology came into being, and how anthropologists subsequently introduced new ways of thinking about such forms.

The Objects of Others as "Curiosities"

The objects of other Cultures were of popular interest to Europeans well before anthropology emerged as a formally recognized field of study. In the 16th century newly "discovered" peoples in Oceania, Africa, and the New World were coming to the attention of Europeans. Early explorers brought back to Europe objects made by these peoples, as well as archaeological artifacts and natural history specimens. In the words of Michael Ames, such forms were viewed as "objects of wonder and delight, to be collected as trophies, souvenirs, or amusing curiosities during ones' travels to far and distant lands" (1985:38; see also Ames 1992).

Europeans of this period did not consider any of these objects to be art forms, for reasons that I will take up shortly. Instead, these objects were displayed by their collectors as proof of their daring exploits. Such objects were also collected and displayed by wealthy Europeans including members of royal and noble households, where they served as signs of the privileged status of their owners and evidence of their special knowledge of the world.

The wealthy owners of these objects kept them in special cabinets called **Cabinets of Curiosities** or **Houses of Curios**, and any given cabinet could contain a wide array of cultural and natural objects that had originated from different places and time

periods. Such objects were arranged in these cabinets according to the whims of each individual collector.

The Objects of Others as Commodities

At the same time that such objects were of popular interest in Europe and brought prestige to their owners, they came to be viewed as commodities with a market value. As art historian Ruth Phillips notes (in Bruck et al. 1986:254), there have been markets in Europe for such archaeological and ethnographic objects since the 18th century. Such markets continue to exist today throughout the world. The popular *American Indian Art Magazine* regularly reports prices currently being paid for American Indian artifacts at auctions held both in Europe and North America.

New Views in the Emerging Discipline of Anthropology

The early belief that the objects of geographically distant non-Western peoples were merely curiosities to be displayed for personal status was challenged when formal academic disciplines emerged in Europe. The founders of these disciplines turned to such objects for evidence to support their theories. In the case of anthropology, which emerged as an academic discipline in the mid-1800s, human artifacts from both prehistoric societies and from remote non-Western ones became valued scientific data to support early theories about the evolution of human society.

It is important to stress that early anthropological theories of evolution both reflected and more fully articulated ideas about evolution that were already widespread in the West. In particular, 19th century anthropology took up the idea that human societies had passed through a series of stages, each characterized by certain kinds of social, economic, and political forms, as well as by (predictable) types of material objects.

Central to this early evolutionism was the idea of **progress**, that is, the notion that more recent stages were superior to earlier

ones both in terms of their cultural and their moral accomplishments. While the people in the West were thought to have progressed to the highest stage of evolution (labeled "civilization"), societies located in distant lands, which were by then being colonized by the West, were thought to have "progressed" no further than the earliest stages of the evolutionary sequence. These were presumed to be stages through which the West had already passed.

The influence of these early ideas about evolution on an emerging anthropology cannot be emphasized too strongly. While anthropology was to become the study of people different from people in the West, its early link with evolutionary ideas meant that it began with a potent presumption about how such differences among the peoples of the world were to be understood. That is to say, there was the early presumption that people were different because some had supposedly "progressed" further than others. And some people were presumed not only to be more "advanced" technologically, but their way of life was also considered to be morally superior.

As Johannes Fabian has shown (1983), these early ideas about evolution influenced the very way in which anthropology identified its particular topic of study (what Fabian refers to as anthropology's "object of analysis"). That is, presumptions about the evolution of human societies influenced how the discipline of anthropology initially identified which non-Western societies were to be its special focus.

As Fabian continues, during the Renaissance and the Enlightenment, the different Cultures of diverse peoples had been accepted in the West as temporally coexistent (that is, as alternative ways of living that coexisted in time with those of the West). However, with the crystallization of evolutionary ideas by the early 19th century, cultural differences came to be understood in a radically altered way: differences came to be perceived as the inevitable outcome of the operation of a natural law of evolution; evolution was seen as inevitable; and anthropology became the study not only of this evolutionary process but, in particular,

the study of those societies which had not followed this process (that is, "progressed") as far as the societies of the West.

That is to say, the societies that came to concern anthropology were those thought to represent stages of socio-cultural evolution through which Western society was presumed to have already passed before its attainment of "civilization." Such societies were persistently referred to as "primitive" in contrast to the so-called "civilized" societies of the West. And so anthropology became the study of so-called "primitive societies."

It is also important to stress here that those societies conceptualized as "primitive" were the very ones that were subjected to Western conquest and colonization. Some critics now argue that this was not an accidental development, but one whereby anthropological theory served to legitimate the oppression and exploitation of non-Western peoples by claiming they were backwards and inferior to the peoples of the West.

The Objects of Others as Scientific Data

These 19th century theories of evolution within anthropology engendered new ideas about the objects of other Cultures. As anthropology became the study of so-called "primitive" peoples, the social and material forms of these other peoples became more than mere curiosities or commodities in an emerging market economy. Instead, as early anthropologists sought to amass "scientific" facts to substantiate their current theories of evolution, the objects of so called "primitive" peoples became scientific data. (For an excellent account of how this resulted in a scramble by anthropologists to collect Indian artifacts on Canada's West coast, see Cole 1985.) That is to say, these "data" constituted evidence for generalizations by anthropologists about human societies, including their belief that different societies represented different stages of an evolutionary process.

While the objects of other Cultures were now elevated, so to speak, to the status of scientific specimens, they were not (yet) thought of as works of art. Indeed, the inability on the part of Westerners (including Western anthropologists) to conceptualize

so called "primitive" objects as art forms was itself the result of evolutionary presumptions. For given the belief that so-called "primitive" societies were less advanced than the societies of the West, their members were not thought to be capable of producing art in the sense that art was made in the West.

Of course this view was highly ethnocentric, given its presumption that true art had to be like the art that was then being made in the West. Reinforcing this presumption on the part of Westerners, as Maquet has noted, was the fact that Western art of this period tended to be highly representational (1971; see also Maquet 1986). That is to say, the aesthetic style that dominated Western art in the mid 1800s was **academic naturalism**, a style characterized by its attempt to accurately represent the world as it appears to the human eye. The fact that many objects from so-called "primitive" societies did not conform to these naturalistic canons of the West reinforced ideas in the West that such objects could not be considered art.

Human History Museums

One of the ways in which anthropology has communicated its (changing) understandings about other societies and their objects is through museum exhibits. It is therefore useful to include in this chapter a discussion of the changing ways in which Western museums have exhibited the objects that are of interest to anthropologists.

Museums as we know them first became popular in the West in the mid-1800s at the same time that academic anthropology was being established. Museums of natural and human history became public institutions in which anthropological ideas about other Cultures were communicated to a wider public (see Stocking 1985 and Bennett 1995). In some cases, the unsystematic and idiosyncratic collections of curiosities of the wealthy became the basis for major museum collections in Europe (Ames 1985:38; see also Ames 1992). Professional museum staffs, schooled in the anthropological thought of the day, transformed these as-

sortments of curiosities into organized collections of scientific specimens, and they introduced systematic procedures for collecting, analyzing, classifying, and displaying objects.

According to Ames:

> A typical objective of early anthropological displays was, therefore, to present artifacts from primitive societies as if they were specimens akin to those of natural history. Following the tradition of the Cabinets of Curiosities, primitive peoples were considered to be parts of nature like the flora and fauna, and therefore their arts and crafts were to be classified and presented according to similarity of form, evolutionary stage of development, or geographical origin. The comparative theme was the essential ingredient. (Ames 1985:39)

As Ames continues, some museums of natural and human history still adhere to this early anthropological strategy in their exhibitionary practices.

The Idea of "Primitive Art"

The Objects of Others as "Primitive Art"

During the early 1900s, there were developments which radically changed the ways in which the objects of people then referred to as "primitive" came to be viewed in the West. Significantly, these developments did not come primarily from within the fledgling discipline of anthropology, but rather from individual Western artists.

As Goldwater has detailed (1938), these artists came upon the objects of non-Western peoples which were then available in the curio shops of Europe and increasingly on exhibit in early human history museums. Among these artifacts were carved statues and masks that had been collected in Oceania and Africa, many of which represented the human figure.

Western artists were interested in these carvings because of the ways in which they represented the human figure. Importantly, their interest was not in the meaning or the function

of these objects in the Cultures where they had been made. Instead, Western artists were attracted to these forms because of the innovative ways in which their makers had dealt with certain aesthetic problems, in particular with how their makers had handled technical problems that visual artists must solve regarding the interrelating of masses and volumes (Goldwater 1938). These objects had been made in a way that constituted a radical contrast to the then privileged aesthetic style in the West of academic naturalism, and they provided Western artists with models to break away from such styles and produce more abstract works.

As well as their interest in their more formal aesthetic characteristics, Western artists considered these objects also to express "a Primeval spirit of strength and freedom" (Maquet 1971:3). Therefore, such objects also provided these Western artists with models for producing what they considered freer, more individually expressive art.

There are two important points to make here. The first is that objects of peoples viewed as "primitives" become reconceptualized as art *only* as part of a process whereby ideas in the West about the nature of art itself were challenged and changed. As Maquet has put it:

> ... the first recognition of the artistic character of objects made in nonliterate societies was achieved by reference to Western art and not to the traditions from which the objects originated. (1971:3)

As Maquet continues, in many cases these objects had not been intended as art objects in their societies of origin, though of course some might have been. Such objects became art by a process of metamorphosis. They also came to be viewed in the West as art objects because artists, museum curators, art dealers, and the public included them in the West's **art circuit** — that is to say, they became commodities bought and sold in an organized market, a network that Maquet argues is a first step in defining art in the West.

Art by metamorphosis is contrasted by Maquet with what he calls **art by destination**. Art by destination is produced explicitly for the art market.

The second point to be made here brings us directly to the origin in the West of the term "primitive art." Despite the fact that objects of peoples labeled "primitive" were given a more prestigious status in the West as "art forms," they were nonetheless referred to not as "art" *per se* but as "primitive art." This new category "primitive art" was not without its problems, for the idea that there could be "primitive art" seemed to reinforce the idea that there were also "primitive" peoples. I will return shortly to this problematic and contradictory situation.

As a result of the new category "primitive art," new kinds of museum exhibits came into being. Before considering them, however, I want to discuss changes that were taking place in anthropology at the same time that Western artists were inventing the category "primitive art."

Challenges to Evolutionary Presumptions

During the early 1900s there were also changes taking place in the discipline of anthropology which affected the ways in which the objects of distant non-Western peoples came to be rethought. In particular, the evolutionary presumptions that had dominated the discipline during the 19th century were increasingly criticized. It was during this period in the history of anthropology that the Culture concept, as discussed in Chapter 1, began to crystallize in anthropology (see Barrettt 1996 for an excellent summary of the history of methods and theories in anthropology). Increasingly the view was taken that other Cultures should not be investigated as representatives of preordained stages through which all humankind had necessarily "progressed," but as alternative ways of life. Increasingly many anthropologists argued that different ways of life constituted alternative ways of adapting to the natural world.

Changing Perspectives

It was also during the early decades of the 1900s that other distinctive features of anthropology (also discussed in Chapter 1) were formulated. Among these were the stance of cultural relativism and the method of participant observation.

Two new theoretical perspectives engendered these changes (although the first of these perspectives was avowedly atheoretical). The first emerged in North America, where Franz Boas argued for an anthropology that treated each Culture as an alternative way of life. Boas advanced a new perspective called **Historical Particularism** whereby each Culture was to be described and valued for itself, not as representative of a stage in some preordained evolutionary sequence. That is, Historical Particularism rejected theorizing in favor of detailed descriptions (ethnographies) of Cultures based on participant observation. Boas is generally considered the founder of professional anthropology in North America, and his influence on the discipline in North America was enormous. His ideas influenced a whole generation of young anthropologists, many of whom were his students. Under his direction, they undertook participant observation fieldwork among the aboriginal peoples of the New World as well as non-Western peoples living in other parts of the world.

The second theoretical perspective to emerge within anthropology during the early 1900s was **Functionalism.** Here the view is advocated that each Culture has functional unity, that is, that each way of life constitutes a set of interrelated components that together ensure its ongoing survival. For many practitioners, the purpose of anthropological interpretation thus became the determination of how a society constituted an adaptive system, and in particular how each part, or component, of a Culture contributed to its ongoing maintenance and survival.

It was during this period that the speculative writings of 19th century (evolutionary) anthropologists were largely replaced by accounts of other Cultures based on direct observation by anthropologists who spent long periods of time living with remote, non-Western peoples. This, then, was the period that saw the invention of participant observation as a method of gathering data in the field, and the period when the ethnographic monograph

became the dominant text for the discipline. But nonetheless, as I will take up in more detail in Chapter 6, some of the "language" of early anthropology persisted, particularly the designation of anthropology's object of analysis as "primitive Cultures."

In particular, it was during this period that anthropologists took up the category "primitive art" originally advanced by Western artists. Anthropologists devoted chapters of their monographs to the aesthetic expressive forms of the peoples they studied, and they began to offer insightful analyses of the functions these forms played in the Cultures where they were made. Boas himself wrote a book entitled *Primitive Art* (1927).

It seems to me, however, that this acceptance by anthropologists of the category "primitive art" was contradictory, given the simultaneous critique within anthropology of the evolutionary ideas that had led in the first place to the positing of a "primitive stage" of humanity. Nowhere was this contradiction more apparent than in the museum practices of the period as debates ensued regarding how to exhibit objects now categorized as "primitive art."

New Kinds of Museum Exhibits

Let us return, then, to the changing ways in which the objects of interest to anthropology were exhibited in museums in the early decades of the 20th century. We have seen that objects initially considered mere **curiosities** (but also **commodities**), and then **scientific data**, came to be thought of as forms of "**primitive art**" in the early 1900s. We have also noted that although the idea of "primitive art" did not originate among anthropologists, the term "primitive art" was nonetheless increasingly used by them to refer to the expressive cultural forms of non-Western peoples.

This new view that some ethnographic (and archaeological) objects were forms of "primitive art" led to new kinds of museum exhibits, including the inclusion of the objects of non-Western peoples in the exhibits of art institutions. Such exhibits in (mainstream) art museums have been called **formalist exhibits** by

Ames. As Ames (1985:40) notes, ethnographic objects came to be displayed as forms of "fine art" by formalists, that is, by professional museum curators who were concerned with the objects as "art," rather than in terms of the particular role or function they had served in the societies in which they had been originally produced. For them, "form [had become] more important than content" (Ames 1985:41). Western curators of art looked to the material culture of these remote societies for objects that could be considered fine art forms within the newly renovated Western category of art.

As Maquet notes with regard to these new formalist exhibits:

> Objects assembled under the heading of art were representations of men, women, animals, and artifacts showing ornamental patterns. In most cases it was clear that the objects had been selected because they somehow corresponded to the Western idea of an art object. (Maquet 1971:3)

This view that the objects of others are "primitive art" has persisted to the present day among some museum workers as well as some art dealers and members of the public. Indeed, this view has fueled the continuing commoditization of such objects. As we saw earlier in this chapter, markets for such art are now widespread, and like other fine art forms, very old and rare pieces have increased in value, making them good investments. Sometimes the rare, old pieces are even worth more in the marketplace than a new piece made by a direct descendent of the older work's maker (see, for example, M'Closkey 1994:214). As in earlier times, the possession of such "primitive art" is a mark of social status among affluent members of Western societies.

But during the early part of the 20th century, there were other developments which seem at odds with the acceptance by many anthropologists of the idea of "primitive art." Influenced both by Historical Particularism and the functional perspective in Anthropology, many museum-based anthropologists rejected formalist exhibits. They argued that such formats displayed objects out of context so that their meanings and functions to the people who produced them were obscured. Moreover, such for-

mats violated anthropology's stance of cultural relativism because the (aesthetic) standards for selecting works as "art" were based on Western aesthetic norms. Formalist exhibits did an injustice to the people whose objects were exhibited because they failed to represent "the native point of view" (Ames 1985:42).

There were, it seems to me, two contradictions present during the early part of the 20th century — contradictions that, in some cases, persist today. The first contradiction was that many anthropologists began to use the term "primitive art" to refer to the expressive forms of the peoples they studied, while at the same time rejecting (formalist) exhibits of non-Western objects which displayed these objects on the basis of their aesthetic characteristics. The second contradiction, as I have already suggested above, was that anthropologists offered ethnographic accounts of "primitive art" while at the same time rejecting theories of socio-cultural evolution, thus implying that there were no "primitive" peoples, but that there could be such a thing as "primitive art."

In the case of museum exhibits, what then did anthropologists offer in the place of formalist exhibits? Instead of formalist exhibits, or the older exhibits in which objects were displayed as specimens representing evolutionary sequences, anthropologists began to advocate what, following Ames, we can call **contextualist exhibits**. According to Ames, it was Boas who "... popularized a different form of anthropological display" in which objects were exhibited "in fabricated settings that simulated the original cultural contexts from which they came, rather than as natural history specimens representing some typology or evolutionary sequence" (1985:40). The intent of contextualist exhibits is to reconstruct the way that objects have been used in their original cultural contexts and therefore to present a "native point of view" (Ames 1985:40).

While contextualist exhibits have today become a very popular type of exhibit in anthropology museums, some fine art institutions have continued to mount formalist exhibits of so-called "primitive art." Furthermore, the formalists have not ignored critiques by anthropologists of their exhibitionary practices. As

Ames remarks, for some of them the anthropological contextual exhibit is

> ... no less an arbitrary arrangement than the old curiosity cabinet, because the simulated context of the exhibition represents the mental reconstruction of the anthropologist further elaborated by the technical artistry of the exhibit designer. Such exhibitions, the formalists suggest, may tell us as much about our own exhibit technology and fashionable theories as they do about the cultures contextualized therein. (Ames 1985:41)

Formalist and contextualist exhibits are still the dominant exhibitionary formats today. According to Ames, the so-called formalists and the contextualists

> ... are usually willing to tolerate differences providing the formalists remain in art museums and the contextualists remain in their museums of anthropology and natural history. Only when boundaries are crossed do people get agitated or confused. If a museum of anthropology displays the material workings of a tribal society as fine art ... then a boundary is violated, categories have become mixed, and people are likely to become disoriented and upset. (Ames 1985:41–42)

Increasingly, however, these boundaries are being blurred according to James Clifford who has analyzed the ways in which four museums in British Columbia exhibit the aesthetic cultural forms of Indigenous Peoples of Canada's Northwest Coast. As Clifford writes:

> ... the familiar argument in major art and anthropology museums over the relative value of aesthetic versus scientific, formalist versus culturalist [i.e., contextualist] presentations seems to be giving way to tactically mixed approaches. Some degree of cultural contextualization is present in all the museums I visited. So is an aesthetic appreciation. Indeed, the most formalistic treatment in my sample occurs in an anthropology museum, with a resulting impression of art as cultural process. (Clifford 1991:224–25)

Clifford also notes that exhibiting cultural forms as "fine art" can have very positive consequences. Despite the controversial nature of such exhibitionary practices, they can be sources of both "native power" and also economic rewards for the aboriginal peoples whose cultural forms are exhibited (1991:251 n. 10); they can provide "effective ways to communicate cross-culturally a sense of quality, meaning, and importance" in ways that do not "simply equate non-Western and Western aesthetic criteria" (1991:225).

Clifford's point here is an important one, acknowledging as it does that innovative museum exhibits are increasingly being mounted in Canada, including exhibits put on by the aboriginal peoples whose cultural forms are on display. I will have more to say about such innovative museum exhibits in the Conclusion to this book.

Summary

In this chapter, I have reviewed anthropology's changing ideas about expressive, aesthetic forms. As we have seen, for the most part anthropology has been interested in the cultural productions of non-Western others.

We have also seen that anthropology's (changing) approach to studying art has been influenced by ideas and developments in the wider (Western) world. Thus, the dominance in 19th century anthropology of evolutionary presumptions about socio-cultural stages virtually precluded its viewing the objects of geographically distant non-Western peoples as "art." Indeed, given the presumptions of Western superiority that were inherent in this evolutionism, remote non-Western peoples were thought too "primitive" even to make art.

But evolutionary presumptions in anthropology were challenged as professional anthropology matured in the 20th century. A belief in cultural relativism, fieldwork based on participant observation, and the analysis of Cultures as functioning

systems with their own distinct ways of adapting to the natural world took hold.

At the same time, the idea that remote peoples (as well as prehistoric peoples) produced "primitive art" gained acceptance among Western artists and art connoisseurs, and also among anthropologists. But this led to contradictions within anthropology, including, firstly, the acceptance of the category "primitive art" but the rejection of a category of "primitive societies" (or "primitive Cultures"), and, secondly, the view that there was "primitive art," but that formalist exhibits of this art were unacceptable.

The process by which new ideas about the aesthetic forms of others have come into being in the West is a complex one. New ideas have not simply replaced older ones. Rather these alternative, and often contradictory, ideas about cultural forms persist, and coexist, in various guises among anthropologists and members of the wider public. For example, today Western tourists visit the peoples studied by early anthropologists. In many cases, objects once produced by these people for local use and subsequently "collected" by anthropologists have now been commodified as tourist art (see Blundell 1993b, 1994 and 1995–96). Such objects are now purchased as souvenirs by travellers who take them home and display then in what can only be considered contemporary manifestations of 19th century Cabinets of Curiosities.

Chapter 3

Art as Signification

One of the most widely embraced perspectives on art to emerge within a maturing anthropology is the view that art forms communicate important cultural meanings. The purpose of this chapter is to consider the argument that art can be understood in terms of the meanings it conveys. This argument requires us to consider those theories which attempt to account for art's signifying capacity. Therefore, I will review anthropological ideas about signification as well as concepts and theories developed within semiotics, a field which has influenced recent anthropological studies of art.

The point of departure for this chapter is the wide recognition that works of art have the capacity not only to arouse our pleasure but, also, to convey meanings. How, precisely, do art forms signify meanings? To answer this question, it is necessary to begin by reviewing briefly more general arguments regarding the nature of signification.

The Nature of Signification

In arguing that art communicates (or conveys, or signifies) ideas, or meanings, we are saying that art is one of a number of **systems of signification** by means of which humans attribute meaning to their experiences and thereby order their world. Such a view leads us to distinguish between experience, on the one hand, and knowledge or understanding, on the other. Although we experience the world directly, many anthropologists would argue that

35

our understanding of the world is possible only because we are able to represent the world through signification, in particular through language.

Indeed — and this is the critical point also made in Chapter 1 — many anthropologists consider members of each Culture to have their own distinctive view of the world, a view which is both produced (i.e., constructed) and reflected in language, and a view which engenders cultural practices that permit humans to survive and sustain themselves. As one anthropologist has written, such a position therefore challenges the notion that humans deal with the world "simply as it is; as it would be defined by physics or biology" (Bloch 1983:29). Instead, it is argued that humans "apprehend the world through a system of meaning" which we learn as members of social groups, and "of which language is an essential part" (Bloch 1983:29).

Proponents of this position are advocating a form of **materialism** (see Chapter 4) in that they consider the ideas that humans hold about the world (what anthropologists often refer to as a Culture's **world view**) to be constructed by them within the context of their everyday social life (although the process by which ideas arise and are maintained is, as we shall see in Chapter 5, a complex one). Indeed (as Bloch and others who distinguish between our experience of the world and our meaningful knowledge of it stress), such (socially constructed) meanings in fact constitute human consciousness (see Bloch 1983:29).

Many anthropologists consider the social construction of meaning, which anthropologists often refer to as **symbolic behavior**, to be the characteristic that distinguishes humans from other animals. This ability to signify is not only a pre-eminent characteristic of all humans, but different ways of life or anthropological "Cultures" and "subcultures," constitute alternative ways of attributing meaning to the world and, therefore, alternative ways of understanding and adapting to the world.

Indeed, many anthropologists argue that the ability to signify has been crucial to the biological evolution of humans, as processes of biological selection brought about the emergence of large brained, bipedal culture-bearers from the small brained,

ape-like forms that are thought to have been our ancestors. That is to say, palaeo-anthropologists believe that the distinctive morphology of humans (including human cognition) is the result of selection for the complex biogenetically coded brain-based structures that permit our signifying behavior. While early humans left direct evidence of their linguistic behavior only when they began to write, archaeological evidence of human signification in the form of art is as old as our species, with early evidence going back some 100,000 years and well-developed representational art dating to about 35,000 years ago (see, for example, Jurmain et al. 1987).

Semiotics

As well as being grounded in anthropological theory, the view that art is a system of signification also draws upon the arguments of **semiotics** (also called **semiology**). Often called the "science of signs," semiotics has itself been influenced by developments in modern structural linguistics, where spoken or written languages are generally put forward as the systems of signification *par excellence* (see Hawkes 1977:124–25).

Linguistic Signification

Structural linguistics has provided semiotics with is core concepts, most particularly those of the **sign** and **signification**.

Signs are employed to express ideas, that is, they are central to a process called signification. A sign consists of two components: there is, firstly, "a sound or acoustic component," called the **signifier**; secondly, there is "a mental or conceptual component" which it evokes, called the **signified** (Sturrock 1979:6; cf. Silverman 1983:6). It is important to stress that the signified "is not a thing but the notion of a thing ... which comes into the mind of the speaker or hearer when the appropriate signifier is uttered" (Sturrock 1979:6).

Anthropologist Jacques Maquet summarizes the process of signification as follows:

Changing Perspectives

> The function of a semiotic system is communication. The simplest relationship of communication includes two actors, the sender and the receiver, and what is sent and received, the message. The message is not an object, but what an object means; it is the signified supported by the signifier. (Maquet 1971:32)

The world itself (or "reality") which is directly experienced but made meaningful only through this process of signification is thus the **object** or the **referent** of signification (Silverman 1983:16).

It follows from what has been said thus far that the meanings of linguistic signs are arbitrary, that is, no necessary link exists between any given word and its associated referent. As Maquet writes: "The Latin word *sol*, for instance, refers to what it signifies — the sun — by pure convention; any other Latin word could have been chosen" (1971:33).

Not only are the meanings of words socially constructed and agreed upon by those who employ them, but they can be modified or even radically transformed through time.

Two additional concepts are central to modern semiotics; namely, those of **codes** and **sign systems**. The meanings of messages are the same for both sender and receiver because they share a common linguistic code: The sender of a message

> converts what he [sic] wants to communicate into "signs" according to [this] code. [That is s/he *encodes* meanings.] Then the receiver *decodes* (or deciphers), translating the communication from "signs" to meanings, according to the same code ... (Maquet 1971:33, my emphasis; cf. Sturrock 1979:7)

However, signs cannot signify in isolation, but assume meaning only in relationship to one another. As Sturrock writes, signs are "constituted by the differences that mark them off from other, related units" (1979:10). Thus a sign is a "relational entity, a composite of two parts that signify not only through those features that make each of them slightly different from any other two parts, but through their association with each other" (Silverman 1983:6).

The pioneer of structural linguistics, Ferdinand de Saussure (1960), took account of three kinds of systemic relationships in

linguistic signification. The first is the relationship between a signifier and its signified. The second, called a **paradigmatic relationship**, is "between a sign and all of the other elements of its system." And the third, called a **syntagmatic relationship**, is "between a sign and the elements which surround it within a concrete signifying instance" (Silverman 1983:10). In the process of signification, "[m]eaning emerges only through the play of differences within a closed system (Silverman 1983:9).

Aesthetic Signification

While languages are generally put forward as the most complete and rigorous semiotic systems, the model of language as a system of signs has been applied to other "domains of sign usage," including art (Mukorovsky 1976a:3; cf. Silverman 1983:6 and Maquet 1971:32; see also Winner 1978:337, 346–51). Like the elements of articulate speech, art forms can be employed as signs in the process of signification because they are capable of meaningful interpretation. The perceivable forms created by artists constitute such aesthetic signifiers. Examples include the images of paintings, postcards, or television programs, the decorative elements of costumes, the sounds of music, or the movements of dance. Indeed, aesthetic conventions such as the use of certain colors or a particular aesthetic style can convey meanings, as can the absences in a work of art of certain images or a certain style.

Denotation versus Connotation

It is generally acknowledged, however, that there are important differences between the way art forms signify meanings and the way that the words of a language do so when the words are used in everyday speech aimed primarily at communicating information. It is, of course, recognized that language itself can be viewed as an art form when it is employed in, for example, the production of poetry or literature, in dramatic performances, or in the oral rendition of stories or myths. Therefore, some theorists distinguish between the "instrumental" use of language and its aes-

thetic use. One such theorist, Jan Mukorovsky, has been a leading aesthetician of the so-called Prague Linguistic Circle.

Mukorovsky's argument is that words, as signs (in their non-poetic usage), serve the external aim of depicting events, describing events, describing things, expressing an emotion, or stimulating a behavior in the listener (1976b:236). That is, words constitute **"sign-instruments"** for Mukorovsky. Furthermore, the meanings encoded in linguistic signs are said to be "denotative" in nature, and language is referred to as a **"primary" order** or **level of signification**.

However, the process by which linguistic signs are used aesthetically in, for example literature or poetry, is considered to be more complex in nature. Systems of aesthetically used linguistic signs are generally referred to as "second order" systems. In second order systems, the (prior) **denotative meanings** themselves become signifiers in a further level of signification that produces **connotative meanings**.

As Hawkes writes with regard to the aesthetic use of linguistic signs:

> "Denotation" we normally take to mean the use of language to mean what it says: "connotation" means the use of language to mean something other than what is said. And, of course, "connotation" is centrally characteristic of the "literary" or "aesthetic" use of language ... Thus, connotation takes place when the *sign* resulting from a previous signifier-signified relationship becomes the *signifier* of a further one. (Hawkes 1977:133, emphasis in original)

Semioticians also argue that a vast range of non-linguistic forms also enter into **second order signification systems**. Objects and activities as diverse as works of art (broadly defined), forms of popular culture, and marketed commodities have been seen as constituting such signs.

The work of the French theorists Roland Barthes has been particularly influential in demonstrating the affectivity of such non-linguistic signs. In his seminal book *Mythologies* (1957), Barthes considers the way in which diverse aspects of French

life (everything from advertisements to food to public figures) become encoded with such connotative meanings.

Barthes, for example, decodes (or **deconstructs**) the meaning of a wrestling match, and he concludes that viewers of a wrestling match are not only entertained by the event itself but they also receive, as it were, instructions about an appropriate form of social control. Barthes identifies a two-level sign system whereby the initial sign (e.g., the signifier "two men in a ring" and its signified, "a wrestling match") itself becomes the signifier in a second sign. In this example the signified of the second sign is a particular ("eye for an eye") conception of justice.

Following Barthes, let me offer my own example from Canada to show how art can have both denotative and connotative meanings. As a number of anthropologists have noted, artifacts and art forms produced by Canada's Indigenous Peoples have long been depicted in promotional materials designed to attract tourists to Canada. For example, a travel poster distributed in the mid 1980s by Canada's federal tourism agency depicts a solitary totem pole along with the caption "Canada" (see Blundell 1989a, Figure 3). In this poster the visual image of a totem pole denotes the depicted totem pole, which many viewers will know is a characteristic cultural form produced by the aboriginal Indian peoples of Canada's West Coast.

There is also a connotative message here, which is promoted by the caption to the poster. The connotative message is that the totem pole is a distinctively *Canadian* cultural form, and so its image works in this poster as a handy sign of the entire country (cf. Graburn 1976a, 1976b). This connotative message is signified through Barthes' second level of signification whereby the initial denotative sign (the photo of a totem pole and its signified *viz.* an actual totem pole) becomes the signifier in a second sign. In this second sign, that is, in this second level of signification, what is evoked in the minds of many viewers of the poster is the nation of Canada.

Barthes' model, as I have adapted it, is illustrated in Figure 1.

Level 1: *Denotative Signifier* **Poster with Photo of a Totem Pole**	Level 1: *Denotative Signified* **A First Nations Totem Pole**	
Level 1: Denotative Sign: **Level 2:** **Connotative Signifier**		**Level 2:** **Connotative Signified**
Level 2: Connotative Sign **The Country of Canada**		

Figure 1: An Example of Two-Level Signification (adapted from Barthes 1973:115).

The Evocative Nature of Art

Art signifies meaning, but these meanings are not primarily informational in nature. Rather, the meanings signified through art are felt or understood in a more emotional, experiential way. Thus Mukorovsky, as noted above, contrasts aesthetic (or second order) signs with linguistic signs that act as "sign-instruments." According to Mukorovsky, an art form can also communicate as a sign-instrument, for example, as an illustration in a commercial catalogue. However, its significance as "work of art *per se* does not lie in [its role in] communication" (1976b:237). Instead, its essential feature is that it is "non-serving," that is, it "is not oriented toward anything that is outside itself, toward any external aim" but evokes an attitude in the perceiver toward things and toward reality:

> The understanding that the artistic sign establishes among people does not pertain to *things*, even when they are represented in the work, but to a certain attitude on the part

42

of man [sic] toward the *entire* reality that surrounds him, not only to that reality which is directly represented in the given case. The work does not, however, communicate this attitude — hence the intrinsic artistic "content" of the work is also inexpressible in words — but *evokes* it directly in the perceiver. We call this attitude the "meaning" of the work ... (1976b:237, emphasis in original)

For Mukorovsky, then, the words of language act as signs to communicate messages, while art forms act as signs to evoke attitudes.

Clifford Geertz's Semiotics

Within anthropology, there have been some very insightful studies of art's signifying nature (see discussions in Layton 1981). The semiotic perspective on art is perhaps most evident in the work of Clifford Geertz (see, for example, Geertz 1973, 1976). Geertz also argues that aesthetic meanings are embodied in cultural forms in ways that differ from the encoding of messages in linguistic signification. According to Geertz, art forms act semiotically by giving material form to a particular way of experiencing the world.

Geertz is concerned with the small-scale non-Western societies that have generally been the focus of anthropological study. He argues that such a "feeling for life" or "sensibility" is shared by the members of the social group (the Culture) and, indeed, that these "sensibilities" vary from one Culture to another. Geertz advises anthropologists to undertake an "ethnography of signs" in order to determine these "sensibilities" in a particular society (1976:1498).

According to Geertz, this semiotic view of art also provides us with a way to define art cross-culturally. For him, the common feature of the arts throughout the world, and therefore the feature that justifies a cross-culturally valid anthropological category called "art,"

is not that they appeal to some universal sense of beauty ... [but that] certain activities everywhere seem specifically designed to demonstrate that ideas are visible, audible, and —

one needs to make a word up here — tactible, that they can be cast in forms where the senses, and through the senses, the emotions, can reflectively address them. The variety of artistic expressions stems from the variety of conceptions that men [sic] have about the way things are, and is indeed the same variety. (1976:1499)

The Multivocal Nature of Aesthetic Signs

The final point I want to make here regarding the nature of art forms as aesthetic signs takes us to the concept of aesthetic codes. For viewers to "feel" the ideas encoded in art forms, they must know the aesthetic conventions through which these ideas-as-feelings are conveyed. That is to say, they must understand and/or respond to both the denotative and the connotative meanings of aesthetic signs.

Silver (1979) makes this point in a discussion of daVinci's painting of *The Last Supper*. Western viewers who have a knowledge of conventions (such as those employed to represent the central figure of Christ in this painting) will feel, and understand, the sacredness of the scene that is depicted. But as Silver remarks, for Australian Aborigines, who have different cultural understandings, the painting may be seen as merely a frenzied dinner party.

In the example given earlier of the travel ad for Canada which depicts a totem pole, viewers of the ad must be "predisposed" to think of totem poles as characteristically found in Canada if they are to "decode" them as handy signs of the country.

In many cases such connotative meanings of art forms will be easily decoded by viewers (or listeners). For example, the designers of advertisements try to use visual signs whose connotative meanings will be quickly understood by audiences. But many aesthetic codes lack such precision, as Maquet notes:

> ... the signified meanings evoked by aesthetic signifiers tend to be "multivocal" rather than "univocal" in nature; in other words, they can support several meanings (the signifieds) at the same time without being reducible to a single one. (Maquet 1971:33)

44

Indeed, because our attitudes and feelings about the world are complex, and often ambivalent or contradictory, the multivocal nature of aesthetic signs can evoke these very ambivalent or contradictory feelings or attitudes towards the world which are often difficult to convey directly in words.

Therefore, while **multivocal signifiers** will produce ambiguity in linguistic signification, they can be effectively employed in aesthetic signification to express a range of meanings about the world. Moreover, each signified meaning can reinforce the meanings of associated signifieds, thereby giving added potency to them all. And, importantly, this multivocal characteristic of aesthetic signification can allow art forms to convey meanings that are, in the words of anthropologist Abner Cohen (1974:24) "disparate," thus allowing humans to aesthetically express contradictory attitudes or feelings toward the world.

This ability of art forms to encode contradictions about the world means that art is especially important to anthropologists who are concerned about the range of beliefs within a social group. I will return to this consideration in Chapter 4.

Summary

A semiotic perspective on art focuses on the meanings that are signified through art. Such a perspective leads us to ask questions about the sources and consequences of the meanings that are signified. The field of semiotics thus provides a useful perspective for anthropologists who are concerned with understanding the role of art in the wider social context.

In particular, semiotics provides a perspective that allows anthropologists and other analysts to investigate the "ideological" nature of art. Not only is the anthropological investigation of art's ideological nature made possible by the methods of semiotics, but it is also made possible by new perspectives that have been advanced in the interdisciplinary field of cultural studies. It is to the field of cultural studies that I now turn.

Chapter 4

Perspectives on Art in Cultural Studies

Over the past few decades there have been vigorous challenges to the ways in which Westerners, including anthropologists, have gone about studying, exhibiting, and writing about the aesthetic, expressive forms of non-Western peoples. These challenges have led anthropologists to question some of the methods and theories of their discipline, including the value of the functional approach which has informed many anthropological studies of art. Indeed, Functionalism has been the hallmark of much of mainstream North American anthropology.

These challenges also include the claim that anthropological portrayals of non-Western peoples have distorted (albeit unwittingly) the nature of these Cultures in ways that serve the interests of powerful élites in Western nation-states. This is a serious accusation, because anthropological knowledge about many non-Western peoples has had wide currency in Western countries where it has often influenced both popular attitudes and government policies toward these peoples.

Indeed, as we saw in Chapter 2, early anthropologists thought that their knowledge about others constituted objective, value-free information. Therefore, because anthropology has generally been considered the discipline that can provide "expert" knowledge about non-Western peoples, the claim that its knowledge may facilitate the perpetuation of inequities between the West and non-Western peoples has been highly destabilizing for the discipline. It is a claim that has led to a great deal of self-

reflection on the part of anthropologists about what they do and how they do it.

Challenges to anthropological expertise have also arisen at a time when relationships between the West and the non-Western peoples that anthropologists have typically studied have radically changed. The non-Western peoples that anthropologists have generally studied were for the most part colonized by Western nations, but many have now successfully regained their rights to political self-determination and others are struggling to do so. These groups have also become enmeshed in global economic processes. For example, they themselves, are now audiences for mass communication systems and consumers of a wide range of mass-produced cultural forms. Some anthropologists remark that the small-scale societies they have sought to describe have passed into history, and so they must find new ways of understanding the postcolonial (or postmodern) world (see Coombe 1991a, 1991b). That is, as some have put it, anthropology must reconceptualize its "object" of study.

In this and the following two chapters I consider a new interdisciplinary field of scholarship called cultural studies which addresses many of these challenges to contemporary social science, including anthropology. These challenges have arisen in critical forms of social science, including neo-Marxist, feminist, post-modern and post-colonial perspectives which in turn have influenced debates within cultural studies (see, for example, articles in Blundell et al. 1993 and Hutcheon 1988). My focus is on what cultural studies has to offer regarding the study of aesthetic cultural forms, particularly those produced and "consumed" in today's complex, and interconnected world. In this chapter I also return to the influence within anthropology of Functionalism because functional interpretations of contemporary Cultures have come under attack and because I believe cultural studies provides an alternative way of understanding cultural forms.

Critiques of Functionalism

As was discussed in Chapters 1 and 2, many anthropological reports are informed by a functional perspective which conceptualizes each Culture (as a way of life) as a set, or system, of interdependent parts, each contributing to the maintenance of the whole. Many studies of art informed by Functionalism have generated important insights about art and Culture. But critics also see some of them as limited. For example, within a functional perspective, art often gets analyzed solely in terms of how it helps sustain the *status quo.*

Critics consider functional representations particularly problematic because many of them treat Cultures as isolated systems, and fail to take into account the influences of outside, global forces. They are particularly sensitive to the ways in which the world has changed over the past several centuries and argue that contemporary societies (and probably those in the past as well) cannot be represented as isolated from the peoples or the events in the rest of the world.

Furthermore, the meanings encoded in art that are identified by functionally-inclined anthropologists are often put forward as though they are shared by all members of a group. The possibility that there may be alternative, even dissenting, views of the world within a given group is often not raised. This is a point that feminist anthropologists are now raising, noting as they do that most anthropologists have been males who have tended to describe a Culture from the point of view of its male members. Too often, they argue, functional representations of another Culture present the male view as the only view and therefore fail to take into account both the diversity and the conflicts that characterize all human groups. In this way, critics argue, functional accounts of contemporary groups can hide from view processes of exploitation and oppression. (For recent feminist approaches in Canadian anthropology see Cole and Phillips 1995.)

Critics of functional accounts, therefore, argue for alternative methods of studying and reporting that take into account

both the differences, including the conflicts, within human groups and the effects of forces on them from the outside world.

Cultural Studies

The interdisciplinary field of **cultural studies** offers new ways of analyzing art. Cultural studies emerged in Britain in the post-World War II period, and it has both influenced anthropology and been influenced by it. (For a history of cultural studies as it first emerged in Britain, see Turner 1990 and Johnson 1986/87; regarding the impact of cultural studies on Canadian scholarship, see Blundell et al. 1993.)

Cultural studies shares some important premises with anthropology. In particular, cultural studies draws on the anthropological view of Culture as a way of life, thus refuting the more popular (and the more sociological) concept of culture in the West as something having to do with taste or breeding and knowledge of the so-called "fine arts."

Cultural studies also conceptualizes specifically "cultural" forms (i.e., aesthetic, expressive ones) broadly, as does anthropology. Indeed, cultural studies is primarily interested in the aesthetic forms that people produce or encounter in their everyday lives, and so it has studied those forms sometimes called the **popular arts** (or **popular culture**) as well as **mass media forms** such as television.

Influenced by semiotics, cultural studies views such art forms as signifying in nature. Influenced by anthropology, cultural studies advocates detailed ethnographic studies in order to provide rich accounts of just how people use art to construct meanings, and how they read, or decode, art in meaningful ways.

Importantly, cultural studies considers art to be **contingent** in nature. That is, it argues that art must be understood as part of a broader social context, a view that is widely shared by anthropologists, as we have seen in Chapters 1 and 2.

Proponents of cultural studies argue for the contingent nature of art because they do not share the view of many Western art

historians and connoisseurs that art is essentially the product of individual genius (see Wolff 1981 and 1983). They consider this popular belief about the artist-as-genius to be a Western "myth" which not only distorts the real nature of artistic work, but also permits powerful élites to further their own interests at the expense of others, including artists. For cultural studies, not only is the category of art socially produced (and contested), but the way in which art is produced, consumed, and made meaningful is dependent on extra-aesthetic characteristics and developments in the wider social world.

Despite these shared premises, there are important differences between cultural studies and much of anthropology, especially many earlier (functionally informed) anthropological studies of art. For example, cultural studies differs from many earlier anthropological accounts in that its focus is on contemporary cultural forms in the capitalist nation-states of the West. In particular, cultural studies considers the role of culture for minority groups (and subcultures) within large capitalist states. As a result, those scholars influenced by cultural studies have done a great deal of work on how popular cultural forms both reflect and facilitate the construction of the "ways of life" of these groups.

Cultural studies also rejects the functionalist perspective in anthropology which tends to view Cultures as unchanging and isolated ways of life where there is consensus about cultural ideas. While cultural studies agrees with anthropology that the elements that make up a society's way of life (its Culture) are interrelated, and especially that art must be understood within this wider socio-cultural context, cultural studies conceives both this broader context and the nature of art's place in it in a way that is diametrically different from that of Functionalism. Proponents of cultural studies emphasize that Culture is above all a *process* of construction and contestation.

There are two points to stress here. Firstly, for cultural studies the cultural context is fraught with contradictions and conflicts, as some groups attempt to impose their ideas about the world on others (see Chapter 5).

50

Secondly, for cultural studies, such ideas (meanings) about the world are encoded in art forms, and so art is not merely a reflection of ideas originating elsewhere in society but a major means whereby these ideas are constructed and reproduced. Moreover, meanings encoded in art often promote the interests of dominant groups in a society, but art is also a means whereby the ideas of dominant groups in a society can be resisted or negotiated by subordinated groups.

Because of these views, and unlike functional anthropologists, proponents of cultural studies approach aesthetic forms, not in terms of their shared and equilibrium-maintaining meanings, but as sites (sights in the case of visual forms) where there is "struggle" over meanings. That is to say, cultural studies considers the production of aesthetic forms by artists and other cultural workers as well as their interpretation by audiences to be an ideological process that has a specific historical context (as I will discuss further in Chapter 5).

That is to say, cultural studies never asks what is the "true" meaning of a particular work of art, but rather what is its meaning (or alternative meanings) for a particular group (for example, a gender, an ethnic group, a subculture, etc.) at a particular point in time. It also asks how (and why) such meanings have changed from previous ones. And, finally, it asks about the consequences of such meanings. That is to say, cultural studies asks whose interests the acceptance of some as opposed to other meanings will serve.

By understanding the alternative meanings being promoted through art, analysts can gain an understanding of how the political interests of dominant élites in a society are promoted or contested through art; they can investigate what is often referred to as **cultural politics**, or what Turner calls the "**politics of signification**," that is, "the ways in which the social practice of making meanings is controlled and determined" (1990:203).

Cultural studies thus offers anthropologists of art new modes of analysis that take into account the dynamic and the conflictual nature of the contemporary world, where many societies in fact consist of alternative Cultures (they are, multi-

cultural or pluralistic, as some say). As I will discuss in Chapters 5 and 6, cultural studies brings to such analyses the concepts of "ideology" and "discourse" in order to determine the alternative, contested meanings that are encoded in aesthetic forms. Cultural studies thus foregrounds the political nature of art-making and its use, interpretation, or "reception." And cultural studies provides a way to understand the political and ideological consequences of art, in particular consequences that involve the perpetuation of unequal social relations (often called **relations of domination and subordination**).

Culture as A Way of Life and Culture as The Arts

As noted above, while both functional anthropology and cultural studies see art as part of a broader socio-cultural context, they differ as to how they conceive of art's role in that context. While functional anthropologists view the various elements in a Culture as all working together to perpetuate the *status quo*, cultural studies problematizes art's place in the larger "whole." That is to say, in its approach to aesthetic, expressive forms, cultural studies asks specifically *how* art is related to other components of the socio-cultural context.

In the remainder of this chapter, I want to review the way that cultural studies links the specifically *aesthetic* forms of a group with their more general way of life. In order to do so, it is necessary to return to the view that art signifies meanings and to ask specifically where the *source* of these meanings is to be found.

Proponents of cultural studies reject **idealist interpretations of art**, which have a long had currency in the West. Idealist views consider each way of life (each Culture) to be characterized by an identifiable cultural theme. And idealist interpretations consider art to play a privileged role in the wider society in that art is said to make these cultural themes "most evident." Variously referred to as a society's "informing spirit," its "*Zeitgeist*," "sen-

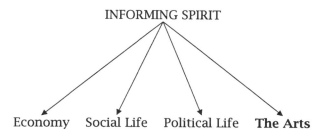

Figure 2: The Idealist View of Art's Relationship to the Broader Culture.

sibility," "central values," "world view," or "ideology," what all of these conceptualizations of the nature of the "cultural theme" share is the view that the source of the cultural theme lies outside the Culture itself.

One of the founders of cultural studies is Raymond Williams. Williams has written about the idealist concept of an "informing spirit." According to Williams, the view taken by idealists is that this "informing spirit":

> ... is manifest over the whole range of social activities but is *most evident* in "specifically cultural" activities — a language, styles of art, kinds of intellectual work ... (Williams 1981:11–12, emphasis added)

The idealist view of art is illustrated in Figure 2.

The idealist view of art has been challenged by scholars who argue instead for a position called **materialism**. Like idealists, materialists see art as a reflection of the dominant ideas of a society, but they challenge the idealist position that the "themes" expressed by art (somehow) originate from outside the wider socio-cultural context.

Many materialists writing about aesthetics in the early 1900s were influenced by the arguments of Karl Marx. Following these arguments, they located the source of these ideas in the economic sphere of society, which they called society's **base**. Art forms were seen to derive from the base, that is, to express ideas that emerged as humans, as social beings, made a living from nature.

SUPERSTRUCTURE (Including the Arts, Ideology)

↑

BASE (Economic Order)

Figure 3: A Materialist View of Art's Relationship to the Broader Culture.

Art belonged to a society's **superstructure**, as illustrated in Figure 3.

Proponents of cultural studies are no happier with these kinds of materialist interpretations of art than they are with idealist ones. For them, such interpretations (which they sometimes call **vulgar materialism**) are far too simplistic in that they fail to acknowledge mutual influences between different areas of social life, for example between the economy and the arts. Nor do such interpretations take into account art's (potentially) subversive capacity. And, finally, such interpretations fail to address the specifically *aesthetic* nature of art, because they reduce art solely to its ideational content.

At the same time that they do not want to fall into this trap of oversimplification, proponents of cultural studies want to hold onto a **materialist epistemology** (that is, a theory of knowledge that considers knowledge — that is, cultural meanings — to be socially constructed, that is, to arise, albeit in complex ways, from the conditions of human life). That is, like many anthropologists, proponents of cultural studies consider the meanings conveyed by art to be determined and agreed upon by humans, living in groups, rather than of extra-social origin.

To resolve this difficulty, proponents of cultural studies not only stress the *contingent* nature of art, as I have noted above, they also (building upon semiotics) stress **art's *constitutive* nature**. That is to say, cultural studies goes further than many

anthropological accounts in its questioning of precisely *how* aesthetic forms are linked with the broader socio-cultural context because cultural studies posits that the aesthetic, expressive forms that are produced and "consumed" in capitalist societies are *especially* potent in (re)producing (ideological) meanings.

In arguing that art is constitutive, proponents of cultural studies are making a point about the way art forms express ideas. They are also stressing that culture is integral to each individual's everyday life, that culture is above all lived experience. That is to say, for cultural studies, art is not merely a reflection of ideas already held by members of a group, but, rather, through the process of viewing (or listening to) art, individuals come to experience the world in a particular way.

In other words, cultural studies argues that art is both a reflection of the context in which it occurs and a powerful force whereby that context is experienced and thereby constructed and accepted as natural and inevitable. The meanings encoded and decoded in art come to be subjectively held. They become part of an individual's consciousness.

As Williams has written, cultural productions (that is, "the arts"):

> ... are not simply derived from an otherwise constituted social order but are themselves major elements in its constitution ... instead of the "informing spirit" which was held to constitute all other activities [this view] sees culture as the *signifying system* through which necessarily (though among other means) a social order is communicated, reproduced, experienced and explored. (1981:12–13, emphasis in original)

As noted above, such art forms are broadly defined in cultural studies to include mass-produced and popular cultural forms, as well as those cultural forms more often considered to be art in the West. This is a conceptualization of "the arts" which is very much in tune with that of anthropology. Therefore, because art is both constitutive and part of an individual's everydayness, it can exercise a great influence over how that individual comes to think about the world and his or her place in it.

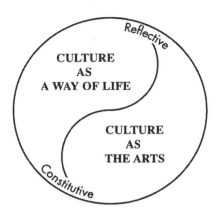

Figure 4: Cultural Studies' View of "Culture" and "The Arts"

For Williams and other proponents of cultural studies, then, the link between "Culture" as a way of life and "culture" as specifically aesthetic productions is a semiotic one. Given the view of Culture as a way of socially constructing the world through signs (see Chapter 3), art forms as signs play a privileged role in constructing and perpetuating a particular way of life because through art humans experience the world in an emotionally loaded way. Art thus shapes, perpetuates, and reflects ideas widely held by a group; art both produces and *re*produces a society's distinctive way of life. And, importantly, art makes a way of life seem natural. This reciprocal relationship is diagramed in Figure 4.

Summary

To summarize, in this chapter I have argued that functional analyses of art are problematic, especially when their focus is the production or reception by audiences of art in the complex world of today. I have suggested that cultural studies can bring to the anthropology of art more useful ways of thinking about the relationship between aesthetic productions and the wider cultural context.

4 — Art in Cultural Studies

While cultural studies has taken up the anthropological concept of Culture as a way of life, it has done so in a critical way. It offers a conceptualization of Culture, including the role of the arts within Culture, that contrasts radically with the view proposed under Functionalism. Indeed, cultural studies replaces Functionalism's static, homogenizing, equilibrium-maintaining perspective on art with an approach that interrogates art forms as sites/sights for the promotion of alternative ways of experiencing and understanding the world in today's complex, often conflict ridden, world.

This perspective suggest that aesthetic forms are especially potent in signifying ideas. And, furthermore, this perspective suggests that the meanings signified through art are neither neutral nor innocent. Instead they can serve the interests of some, though not necessarily all, of the members of a group. This brings us to Chapter 5 and to the argument, advanced in cultural studies, that art is ideological in nature.

Chapter 5

Art and Ideology

New directions in the anthropological study of art include greater attention to the signifying nature of art. Increasingly, art forms are seen as *constitutive* in nature, and therefore many studies now consider how art shapes the ways in which humans experience, understand, and act in the world.

In Chapter 4, I noted that this semiotic perspective on art is shared by proponents of cultural studies who also argue that art shapes human experience, perception and behavior. I noted as well that proponents of cultural studies challenge the more orthodox view in the West that art forms express universal, transhistorical, or metaphysical meanings on the part of artists who are the (sole) sources of these meanings. Instead, advocates of a cultural studies approach argue that the meanings signified by art forms are **contingent** in nature, arising in the context of specific, and variable, social conditions, conditions which are themselves the legacy of prior historical practices and conditions. Most anthropologists would, I believe, agree with these views.

But as I also discussed in Chapter 4, there have been critiques of anthropological studies, especially those informed by Functionalism, because they tend to treat the meanings of a cultural group as uniform, uncontested and unproblematic (that is, as non-ideological). Such critiques have been directed in particular at studies of contemporary non-Western peoples whose lives are profoundly affected by developments such as colonialism and capitalism. Advocates of a cultural studies approach argue that the meanings conveyed by art forms are not only variable

between different groups (Cultures) but are variable *within* cultural groups, indeed that the ideas in circulation within a group are often contradictory and contested. Advocates of cultural studies also argue that widely held ideas can serve the interests of some, but not other, groups or members of a group.

The implications of this critical perspective for the study of art are profound. Rather than being described as a passive reflection of eternal "truths," art is analyzed as a site/sight for the expression of alternative, and often conflicting, ideas held by different groups as well as by different individuals within a group, for example, ideas held by members of different classes, genders, or ethnic groups in complex, nation-states. Indeed, art is analyzed as a site/sight where there are struggles over the meanings that art forms are to have and struggles over who is to determine those meanings.

Such studies, then, consider the **ideological nature of art**. They consider the possibility that the ideas conveyed by art serve the interests of some, but not all, individuals in a society. Such studies therefore make a link between art and political processes of domination, often arguing that dominant élites in a society advance their claims through ideas encoded in art, and subordinated (minority) groups in a society can experience the meanings conveyed by art as natural and inevitable and thereby acquiesce, unwittingly, in their own subordination.

But such studies also take into account the utility of art in processes of resistance: they show how subordinated peoples advance their own claims through art and how they challenge the legitimacy of dominant ideas and advocate alternative ways of experiencing — and acting — in the world.

In this chapter, I will develop the argument that art forms are ideological in nature. To do so, it is necessary to begin by considering what is meant by the term "ideology."

The Concept of Ideology

Debates about how best to conceptualize this frequently used term are notorious (see, for example, Thompson 1984:4). In a general sense, a group's ideology refers to its distinctive set of ideas about the world, what some anthropologists have referred to as a Culture's world view. But, as I will elaborate a bit further along, the term has also been used in a more critical way.

To understand what is usually meant by ideology, it is necessary to return to the argument that our ideas about the world, that is to say the meanings we attribute to our experiences, are the product of social convention. This, as we have seen earlier, is a view that is advanced by anthropologists, semioticians, and proponents of cultural studies.

The premise that ideas are socially constructed was also elaborated in a critical way in the work of Marx and Engels whose perspective has become part of so-called Marxian and neo-Marxian scholarship, including much of the analysis that is undertaken in cultural studies. Marx and Engels start from the belief that ideas have been produced as people have engaged in the natural process of human production and reproduction "as an aspect of the general enterprise of making a living from nature" (Bloch 1983:27). As noted earlier, this position, known as **materialism**, rejects the counter position of **idealism**, which "sees the basis of human existence as abstract spiritual concepts whose origin cannot be explained by natural circumstances" (Bloch 1983:27).

According to Marx and Engels, such ideas are not "simply an automatic product of reflection of physical existence," a position, as I noted earlier, that is sometimes referred to as **vulgar materialism**. Instead, such ideas "originate in material activity" which is undertaken as a *social* activity "and in the human capacity to reflect on such activity" (Wolff 1981:51). As Bloch makes this point, the process by which ideas are produced is "in part an aspect of the interaction of men [sic] grouped together in a society and engaged in production" (1983:17). Human existence occurs in terms of these ideas, "which are incorporated in their mode of life and their subjective experience [their consciousness]" al-

60

though "it is from man's [sic] interaction with nature and from the history of this interaction that these ideas, beliefs, and values are created in the first place" (Bloch 1983:27).

This process by which ideas are produced is a complex one, and it has been the subject of a huge and contentious literature over the past many decades (with heated debates as well about what Marx and Engels really meant in their writings). Maurice Bloch, an anthropologist, offers this summary of the process:

> ... at any particular time people apprehend natural material circumstances through their ideas, and they therefore act in terms of these ideas, beliefs, and values. Therefore, in history it is not nature and technology which makes human society but it is man [sic] himself, who in terms of his already existing ideas and values, makes his [sic] own history, as he [sic] encounters nature and the problems it poses. These already existing ideas and values are, however, themselves the product of previous encounters and answers to the challenge of nature. This means that the relation of ideas and practical problems can only be understood as part of the process of history. Ideas and concepts held by people are not therefore simply a reflection of how nature is at any particular time; they are the historical product of the need to organize society so that human beings in society can produce and reproduce. Ideas and concepts may thus be in fact misleading as to the real conditions of existence; they are not the *reflection* of the economic system but the product of a complex historical process of changing adaption. (1983:27–28, emphasis in original)

Therefore, rather than denying the importance of ideas (as is sometimes incorrectly believed of materialists), this Marxian view asserts:

> ... that ideas ultimately have a material origin in the real conditions of existence, a history which consists in a complicated interplay and conflict of different factors, some directly material, some mental (though material in origin). This interplay and this conflict are the driving forces of history; they are a process which Marx referred to by the word "dialectic" ... [that is] the process of movement which characterizes human history is not a smooth development but a

development caused by conflicts and contradictions which lead to temporary resolutions, like two people arguing with each other. It is by this process of conflict and contradictions, caused by a multiplicity of factors all arising from the natural conditions of existence, that history proceeds to the human condition and human ideas current at a particular moment. (1983:28–29)

According to this view, then, the ideas current in a particular society have been produced in a complex historical way. In some societies, such as those that anthropologists have often studied (that is, smaller, non-Western ones which early anthropology labeled as "primitive") the ideas which are current may be held by all, or most, of its members, though this would have to be demonstrated for each case. Marx thought that this had been the case in the societies — then called "primitive" — written about by early anthropologists, although Bloch's book is in part a critique of this presumption (see also Kuper 1988). However, in complex societies "divided into groups of people engaged in totally dissimilar types of activity, the natural consequence ... would be for a variety of 'ideologies' to develop and coexist, each appropriate to a particular type of labour and practice" (Wolff 1981:52).

However, such a multiplicity of ideologies is *not* common in complex societies. Instead, there are ideas that tend to be more pervasive, ideas which tend to dominate in a society. These ideas, according to Marx, are the ideas of the groups in power, and they are generally referred to as the **dominant ideology**. In the case of the capitalist countries of the Western world "where power is based on economic position, and more specifically on relationship to the means of production (though in complex and mediated ways), the ideas which tend to dominate in society are those of the ruling class" (Wolff 1981:52).

To understand why the ideologies of powerful groups become dominant, we need to return to the Marxian view of the complex process by which ideas are produced in history. We have already noted that according to this view "concepts, ideas,

values, and institutions ... are the indirect product of the process of production undertaken as a social task" (Bloch 1983:17).

There is, however, a second process that occurs "side by side" with this first process, which Bloch summarizes as follows:

> The second process is an aspect of the fact that history also involves the development of exploitation, or the domination of one group by another so that the dominant group can appropriate to itself the surplus value obtained from the labour of the other. The relation of classes in capitalist society is for Marx the most obvious example of this process. The development of exploitation also leads to the formation of ideas, concepts, values, and institutions, but these, unlike those produced by the first process, are geared to operating exploitation, and involve giving the appearance of legitimacy to exploitation, as well as hiding its true nature from the exploited. This second process Marx and Engels call "ideology." (1983:17-18)

It is because of its more powerful position that the dominant class in a capitalist society is able to impose its own consciousness on the whole of society.

In other words, in the case of a capitalist society Marxists argue that the dominant ideology is a "partial perspective" which serves the interests of only some members of the entire society and, in fact, that this set of ideas works against the interests of subordinated groups. And although it is possible to show by analysis that these ideas do not serve the interests of subordinated groups, nonetheless, it is often the case that members of these subordinated groups accept the partial perspective of the dominant ideology as their own, in which case their beliefs about the world distort their real conditions of existence. That is to say, subordinated groups take their position as natural and inevitable when it in fact results from the greed of others and the workings of institutions that assure their continued inequality.

Hegemony

However, the extent to which subordinated groups accept the partial perspective of more powerful groups in a society has been

problematized by so-called neo-Marxist scholars. For many scholars influenced by neo-Marxist perspectives, the so-called dominant ideology is open to challenge and opposition. The powerful are succesfull in putting forward the dominant ideology as a universal one *only* to the extent that they are able to exercise **hegemony** over the subordinated group.

The concept of hegemony was articulated by the Italian Marxist Antonio Gramsci. As Bennett et al. write:

> Gramsci uses the concept to examine the precise political, cultural and ideological forms through which, in any given society, a fundamental class is able to establish its *leadership* as distinct from the more coercive forms of domination. (1981:87, emphasis in original)

Gramsci examined the role of intellectuals in hegemonic processes, as well as the various "sites of hegemony — education, the various forms of 'high' and 'popular' culture, and their 'cement' in ideology, popular beliefs, and 'common sense'" (Bennett et al. 1981:187). He was concerned with how ideas that serve the interests of those in power (and the forms, including institutions, which reproduce these ideas) come to be accepted by groups whose interests they do not in fact serve.

The point I want to stress here is that Gramsci was attentive to the cultivation of consent among subordinated groups, rather than the use of force to compel them to act, or think, in certain ways. As Bennett et al. continue:

> If orthodox Marxism has emphasized the repressive role of the state in class societies, then Gramsci introduces the dimension of "civil society" to locate the complex ways in which *consent* to certain forms of domination is produced. (1981:187, emphasis in original)

As Grame Turner further explains, according to Gramsci:

> ... cultural domination or, more accurately, cultural leadership is not achieved by force or coercion, but is secured through the consent of those it will ultimately subordinate. The subordinated groups consent because they are convinced

that this will serve their interests; they accept as "common sense" the view of the world offered them by the dominant group. (1990:66-77)

But as noted above, this hegemony is not advanced by simply manipulating the world view of the masses, who passively accept the ideas being promoted. Rather, for cultural leadership to be achieved, it is argued that

> ... the dominant group has to engage in negotiations with opposing groups, classes, and values — and that negotiations must result in some *genuine* accommodation. That is, hegemony is not maintained through the obliteration of the opposition but through the *articulation* of opposing interests into the political affiliations of the hegemonic group. (Turner 1990:211-12, emphasis in original)

As I shall explain shortly, aesthetic cultural productions are often implicated in such hegemonic processes, and this is why art forms are of interest to critical anthropologists and practitioners of cultural studies.

As the above quote from Turner indicates, hegemony of the dominant ideology is rarely, if ever, fully achieved. Instead, there are ways in which the subordinated groups challenge the dominant ideology and attempt to negotiate other ideologies. These subordinated groups may be based upon class divisions, or other divisions such as gender, generation, or ethnicity (see Wolff 1981:53-54).

Raymond Williams distinguishes between **residual ideologies**, which have been formed in the past but continue to operate in the cultural process, **emergent ideologies**, which are the expression of new groups apart from the dominant group, **alternative ideologies**, which coexist with the dominant ideology, and **oppositional ideologies**, which challenge the legitimacy of dominant ideologies (Williams 1973, 1977, as summarized by Wolff 1981:53). Furthermore, it must be stated that the ideologies of these various groups within a complex society are rarely coherent, but themselves embody contradictions (Wolff 1981:59).

It is not surprising the some anthropologists whose foci are the complex, ethnically diverse nation-states of the contemporary world find these Marxian conceptualizations of ideology appealing, as do anthropologists who are critical of functional interpretations. Both functional anthropologists and those influenced by this Marxian position view humans as inveterate signifiers and see ideas as distinctive, and varying, constructions of social groups. But, as already noted, functional analyses pay scant attention to opposing sets of ideas within the groups they study and instead consider the ideas that make up a group's ideology to work together to assure the ongoing maintenance of the Culture. In contrast, approaches influenced by Marxian conceptions of ideology attribute to some ideas a more sinister role in the exploitation of subordinate groups by dominant ones. Society is viewed in terms of conflict and struggle among groups whose collective ideologies are not only different but in conflict with one another.

Neutral versus Critical Concepts of Ideology

This discussion of the concept of ideology suggests that the term is used in two quite different ways. It is used, firstly, in a general sense to refer to "a system of beliefs characteristic of a particular class or group" (Williams 1977:69, quoted in Wolff 1981:54), and it is used as well by many analysts to indicate their own belief that such ideas are socially constructed in the context of specific social conditions and that ideas, in the words of Janet Wolff, "bear the mark of those conditions," at the same time that they "systematically obscure and deny these very determinations and origins" (1983:16). Furthermore, such ideas are seen to constitute the consciousness of group members (Wolff 1981:54; cf. Bloch 1983:3). Thompson (1984) refers to this more general sense of the term "ideology" as a **Neutral Concept of Ideology**.

The concept of ideology is used, secondly, in a more restricted sense to refer to the ideas of the dominant group in a society which, when taken as natural by subordinated groups, constitute for them a set of ideas that work against their interests —

what some writers have referred to as their **false consciousness** (Bloch 1983:30). This second sense of the concept, that is, its Marxian-influenced use, constitutes according to Thompson a **Critical Concept of Ideology** in that "ideology is essentially linked to the process of sustaining asymmetrical relations of power" (1984:4), that is, to operating exploitation. Studies of ideology informed by this critical conception attempt to determine "the ways in which meaning (or signification) serves to sustain relations of domination" (1984:4). Importantly, many scholars who ascribe to a critical concept of ideology have turned to the work of Gramsci and his concept of hegemony. Rather than viewing ideology as a form of "false consciousness" that is fully imposed on subordinated groups, they argue that a society's dominant ideology is open to challenge and negotiation.

It seems to me that the majority of anthropologists have used the term "ideology" in its neutral sense, in part because of anthropology's functional orientation and in part because there has been the presumption — now being challenged — that the societies studied by anthropologists have lacked the class divisions of contemporary capitalist states.

It can also be argued that anthropologists have used ideology in this neutral sense because they have not had an interest (precluded, in part, by functional views of non-Western small-scale societies) in the ways in which cultural forms are implicated in the reproduction of unequal social relations.

For purposes of discussion, the following working definitions of ideology are offered here:

Neutral and General Working Definition of Ideology: A system of beliefs characteristic of a class or group which constitutes their group consciousness.

Critical and Restricted Working Definition of Ideology: The ideas of the dominant class or group which are promoted as universal but work against the interests of subordinate groups.

Art and the Signification of Ideological Meanings

Critical anthropologists and practitioners of cultural studies argue that the ideas, or meanings, held by the members of any given group are not only ideological in nature but that such meanings also become embodied in a vast range of cultural forms, including cultural artifacts such as paintings, music, dance, buildings, written texts, and so forth (Wolff 1981:55). For example, as I will discuss further in Chapter 6, the published articles about aboriginal-produced art in Canada which circulate as art criticism, art history, or anthropology are ideological in both the neutral and the critical sense of the concept.

Moreover, the ideas that artists attempt to convey in works of visual art are ideological. Indeed, some artists promote "political" messages through their art by using visual conventions that they hope will be widely understood by their audiences. For example, some aboriginal artists in Canada attempt to represent their Indigenous cultures in ways that will be decoded as counter-hegemonic, that is in ways that contest dominant ideas (*viz.* problematic Native stereotypes) about Indigenous peoples (see Ryan 1992 for examples that draw on post-modern aesthetic conventions). Ideology also becomes embodied in cultural institutions, such as schools, art galleries and museums (as was seen in Chapter 2).

My specific concern in the rest of this chapter is how non-linguistic aesthetic forms, such as works of visual art, can signify ideological meanings. To address this topic, let us return to the writings of Roland Barthes, and to his example of the wrestling match noted in Chapter 3. Barthes argues that viewers of such matches receive a lesson, as it were, in what constitutes an appropriate form of social control, although this is a historically specific notion of justice; other societies have different notions, for example, those based on rehabilitation. For Barthes, the notion of justice signified at such an event is part of a "[system] of images and beliefs which a society constructs in order to sustain

68

and authenticate its sense of its own being, i.e., the very fabric of its system of 'meaning'" (Hawkes 1977:131). For Barthes, such ideas are **myths**, and they result from a process he called **mythification**.

Mythification occurs with second order signification systems (see disscussion and Figure 1 in Chapter 3). As both Heck and Hawkes have shown, myth is a "special type of connotation since ... the mythical system is generated in the same way as connotation" (Heck 1980:125). "[W]hat has been established as a *sign* on one level of signification can be 'drained' so that it can then become a *signifier* on *another* level ... " (Hawkes 1977:141–42, emphasis in original). What is critical is that this process of mythification gives to the signified concept — in this example a particular concept of justice — an aspect of inevitability. That is, what is really an ideological meaning becomes attached in what seems to be a natural way to ordinary aspects of everyday life.

With production of such "mythological" meanings, writes Hawkes:

> ... we have, of course, encountered an extremely powerful, because covert, producer of meaning at a level where an impression of "god-given" or "natural" reality prevails, largely because we are not normally able to perceive the process by which it has been manufactured. Barthes' analysis of *semiosis*, in moving *via* Saussure on to this level, begins to take us "behind the scenes" as it were of our own construction of the world. (1977:133, emphasis in original)

Barthes' concept of ideology is the critical one that has been noted above. For him, it is the meanings of the dominant group of society that are encoded by means of this mythification process. That is to say, via this process of mythification meanings which are in fact socially produced in specific historical contexts and serve the interests of those in power are made to seem natural, indeed inevitable.

Myth therefore differs from connotation "at the moment at which it attempts to *universalize* for the whole society meanings which are special to particular (lexicons of) groups" (Heck

1980:125). As Heck argues, *"myths are connotations which have become dominant-hegemonic"* (1980:125, emphasis in original).

One of Barthes' most famous examples shows how the ideological meanings encoded in visual signs can be dominant-hegemonic, in this case the meanings of a photograph on the cover of a popular magazine that appeared in France at a time when there was political unrest regarding that country's (now former) colony Algeria.

Here is Barthes' deconstruction of this image:

> I am at the barber's, and a copy of *Paris-Match* is offered to me. On the cover, a young Negro in a French uniform is saluting, with his eyes uplifted, probably fixed on a fold of the tricolour. All this is the *meaning* of the picture. But, whether naively or not, I see very well what it signifies to me: that France is a great Empire, that all her sons, without any colour discrimination, faithfully serve under her flag, and that there is no better answer to the detractors of an alleged colonialism than the zeal shown by this Negro in serving his so-called oppressors. I am therefore again faced with a greater semiological system: there is a signifier, itself already formed with a previous system (*a black soldier is giving the French salute*); there is a signified (it is here a purposeful mixture of Frenchness and militariness); finally, there is a presence of the signified through the signifier. (Barthes 1973:116, emphasis in original; also cited and discussed in Hawkes 1977:132–33)

Such exercises are sometimes referred to as forms of **deconstruction** (or decoding), and they constitute persuasive demonstrations that non-linguistic signs can have ideological meanings. However, critics from both outside and from within Marxian traditions argue that this approach can lead to a reduction of art solely to its ideological content.

In challenging such reductionism, an increasing number of critical scholars are arguing that there are characteristics of aesthetic, expressive cultural forms that are specific to them. In particular, they argue that, firstly, there is a specially *aesthetic* way in which ideology becomes embodied in art forms, and, secondly, that there are specially aesthetic ways in which art forms

are "apprehended" by audiences (with the result that they evoke emotions such as pleasure) (Wolff 1981, Ch. 5).

How Ideology Becomes Embodied in Aesthetic Forms

Let us begin with the argument that works of art signify ideological meanings in ways that are specific to them, a feature of art that is often referred to as **art's relative autonomy** (see Wolff 1983:88). To say that art has a relative autonomy is to say that the meanings encoded in art are never directly, nor unambiguously, expressed in the particular work under consideration. As Janet Wolff has argued:

> This is not to deny ... that the artist is in some sense the agent of ideology, through whom the views and beliefs of a group find expression. It is to insist, however, that this does not take place in any simple fashion, whereby political, social and other ideas are simply transposed into an aesthetic medium. (1981:63)

Instead, as Wolff states, artistic production:

> ... is itself of complex matter, interposing itself between the ideàlogy of a class or other group, and its expression in aesthetic form. (1981:59)

In other words, the process by which art (and other cultural) forms come to encode meanings is "*mediated*" in complex ways that are specific to particular modes of signification, such as those involved in, say, the production of literature or visual art, or to give examples from my own research, in the contemporary aboriginal produced powwow and in the production of postcards and other souvenirs that link tourism and ethnicity (see Blundell 1993a and 1994).

Such mediations are both enabling and constraining. They make it possible for individuals (or groups) to produce a given work of art, but they also set limits as to how works can or cannot be made (Wolff 1981:61). And such mediations determine

the particular form that ideological meanings will take in a given cultural product.

Recent studies have begun to address the nature of such mediated processes in aesthetic production. For example, Terry Eagleton (1976:45, cited in Wolff 1983:90) has defined a "literary mode of production," while other analysts address the specific processes by which visual art, music, and other aesthetic forms "re-work" ideology in ways that are specific to them. Among these, Allan Ryan (1992) has documented the use by First Nations artists in Canada of visual forms of parody to convey the intended political meanings of their art, while John Shepherd's analysis of music as social text has revealed the "culture-specific" nature of sound (1991, 1993).

Aesthetic Mediation by Means of Conditions of Artistic Production

The sociologist and cultural studies scholar Janet Wolff identifies two ways in which processes of producing art forms are mediated. There are, first of all, the conditions under which art forms are produced, conditions that will affect the ways that ideological meanings get expressed.

That is to say, artists/authors always produce their works under conditions that are particular to a society at a given historical moment (Wolff 1981:62–63). Indeed, as we have seen in Chapter 2, this is a view that would be endorsed by most anthropologists. Such conditions affect not only the nature of the works that artists produce, but also the ways in which they can do so. As Wolff points out, the "conditions of literary and artistic production are themselves part of, and related to, wider conditions of production in society" (1981:63).

Such conditions of artistic production can include those that are technological as well as those that are institutional. For example, feminists have demonstrated how women artists in the West have been systematically excluded and silenced as a result of, among other ideological conditions, their exclusion from art

schools (see Parker and Pollock 1981; Pollock 1988; and Wolff 1990).

Cultural policies of governments also establish such conditions. In Canada, state cultural policy has for the most part deemed that art by aboriginal peoples be collected and exhibited by ethnographic museums rather than in so-called main-stream art galleries. As Ruth Phillips and I have discussed elsewhere (Blundell and Phillips 1983), this is an institutional condition that confronts artists of aboriginal ancestry. Because ethnographic institutions have typically been interested only in aboriginal-produced art that either draws upon styles associated with aboriginal Cultures or makes explicit reference to aboriginal themes, aboriginal artists who use other styles or refer to other themes sometimes find that there is little interest in their work.

Aesthetic Mediation through Aesthetic Conventions

According to Wolff, the second way in which the process of aesthetic production is "mediated" is by the existing "sets of rules and conventions which shape cultural products and which must be used by artists and cultural producers" (1981:64–65). Such conventions determine what can be aesthetically expressed, the style, aesthetic vocabulary, and so forth for such expression, and also what *cannot* be expressed in a particular cultural tradition.

This kind of mediation takes us back to the argument that art signifies meanings in ways that are similar to, though not identical with, signification in language. As noted in Chapter 3, in the case of linguistic signification, receivers of messages understand the message because they share with the sender a common code which is culturally learned. This code has a precision that prevents ambiguity: meanings are converted into signs that tend to be univocal; that is, to have single meanings (which is the denotative meaning). This, of course, is why language is so effective in communicating information.

The argument here is that literary and other aesthetic systems of signification also operate according to codes, but that

such codes are quite different from those of language. Aesthetic systems are characterized by "specific codes and conventions of artistic representation" (Wolff 1983:88) which is a "fundamental aspect of them"; "So art, while being the product of social, political, and ideological functions, manifests its own specificity in this particular sense" (Wolff 1983:88; see also Berger, 1972 for a case study).

> The relative autonomy of art and culture consists in the specific codes and conventions of artistic representation, which mediate and (re)produce ideology in aesthetic forms. (Wolff 1983:88)

As Wolff points out, this recognition that there are such codes, which are specific to different modes of aesthetic production, provides the link between the study of such cultural forms (that is, cultural studies) and semiotics (the study of signs) (1981:64, 66). And this, as Wolff also notes "has contributed enormously to our understanding of how languages and cultural forms operate, and it has also corrected what was a rather simplistic notion of the relationship between social and cultural forms" (1981:64).

It will be useful to quote Wolff further regarding the way in which aesthetic codes mediate the expression of ideology:

> The forms of artistic production available to the artist play an active part in constructing the work of art. In this sense, the ideas and values of the artists, themselves socially formed, are mediated by literary and cultural conventions of style, language, genre and aesthetic vocabulary. Just as the artist works with the technical material of artistic production, so he or she also works with the available materials of aesthetic convention. This means that in reading cultural products, we need to understand their logic of construction and the particular aesthetic codes involved in their formation. Ideology is not expressed in its pure form in the work, the latter acting as a passive carrier. Rather, the work of art itself reworks that ideology in aesthetic form, in accordance with the rules and conventions of contemporary artistic production. For example, in order to understand how a particular painting is subversive, it is necessary to look beyond its

GROUP ⟶ CHARACTERISTICS OF ⟶ AESTHETICALLY EXPRESSED
IDEOLOGY AN AESTHETIC FORM IDEOLOGICAL MEANINGS
 (including conditions of (e.g. visual ideologies)
 production and aesthetic
 conventions)

Figure 5: The Process of Production of Aesthetic Ideologies.

magnified.

explicit or implicit, political content, and to investigate its
particular use of aesthetic conventions, and its position in
relation to other works of art. This is also important be-
cause it enables us to recognize the significant ways in which
certain things — ideas, values, events — are *not* contained in
the text. The conventions of literary and artistic production
may disallow certain statements. Exposing these limitations
in the texts — these silences ... — is an important part of re-
vealing the ideology which lies behind the text and speaks
through it. (Wolff 1981:65, emphasis in original)

This mediated process by which group ideologies are ex-
pressed in art is diagrammed in Figure 5. In the case of visual art
forms, we can usefully refer to the aesthetically expressed ide-
ological meanings which are produced as **visual ideologies** (cf.
Hadjinicolaou 1978).

This discussion of the process whereby ideology becomes
embodied in art forms (and in other **cultural texts**) provides an-
thropologists with a methodological strategy for decoding ide-
ological meanings in such forms. As Wolff summarizes such a
strategy, analysts of art forms must undertake a dual study of
art (1981:66). They must examine "the nature of the ideology
worked by the text and [then determine] the aesthetic modes of
that working" (Eagleton 1976:85, quoted in Wolff 1981:66).

How Aesthetic Forms are Apprehended

I want to turn finally in this chapter to the question of how the
ideological meaning(s) of aesthetic forms are apprehended, that

is, how they are understood (or decoded) by audiences. According to theories of **reception** in cultural studies, audiences bring to their encounters with art forms a whole set of cultural meanings with which they interpret them. These meanings include understandings of aesthetic codes that are specific to various genres of cultural production. Indeed, producers of cultural forms (including so-called fine art and also media forms such as advertisements) attempt to employ conventions whose meanings will be understood by audiences.

But as numerous writers have noted, the "messages" encoded in aesthetic forms may or may not be "read" by audiences, and clearly they will not be if audiences do not share the code that also informs the work (see Chapter 3).

Nor can it be assumed that individuals who see (or hear) a work of art are passive, and do not themselves participate in creative and innovative ways in the process of attributing meanings to art. Indeed, it is a major argument of cultural studies that the meanings of an art work do not reside in it *per se*, although works of art do promote — through conventions and codes — certain meanings. As Turner argues, works of art are "texts" that "construct a specific range of subjectivities for the reader or viewer" (1990:29).

Individuals make art meaningful, and this is an active process on their part. If they share the meanings promoted and do not contest those meanings, then there will be a kind of symmetry to this encoding/decoding process. But individuals may decode meanings that are different than those intended or those read by others because they bring not only a set of cultural codes and conventions to their encounters with art but also their own personal biographies, their social roles, class positions (which are often contradictory), and their awareness of wider events in the society (as for example a current event). And all these can also affect how they interpret the meanings of art.

It is also an important argument of cultural studies that individuals (and groups) will "read" art in ways not intended by producers as a way to resist the meanings that people in control of processes of aesthetic production attempt to impose on them.

76

They try to "negotiate" different meanings, meanings more in keeping with their own interests and view of the world, and in this way the meanings of art forms are both variable, unstable, and subject to change.

Generally speaking, practitioners of cultural studies attempt to understand this process of reception in a way that does not treat audiences as passive but, at the same time, takes into account the power of art to both promote and naturalize a set of meanings and, therefore, convey them to individuals whose interests they may not, in fact, serve. Janet Wolff provides a detailed discussion of the process of apprehending the meanings encoded in art forms in Chapter 5 of her important book *Aesthetics and the Sociology of Art* (1983).

*will ppl read [?]
[?] [?]
@ yuk
if not
what
they
want?*

Summary

Proponents of cultural studies reject the view that it is ever possible to have totally objective, value-free knowledge of the world (because of the nature of signification itself). We know the world only through the categories that we construct in order to know it. And these categories are both arbitrary and a reflection of (as well as a way of promoting) the values and interests of individuals in a specific (and often a local) historical context.

For practitioners of cultural studies, the purpose of analysis is not to determine the "true" meaning of a work of art, but instead to understand what meanings humans attribute to art and what the consequences of such meanings are for social and political life.

In this chapter I have reviewed arguments regarding the ideological nature of art and calls to deconstruct the ideological nature of art's meanings. Such arguments direct anthropologists to studies of art that consider how art forms (re)produce social relations, including unequal ones, as well as ways in which art forms are sites/sights of struggle over what meanings art forms are to have.

Changing Perspectives

There is a further issue regarding the ideological nature of art which I wish to take up in Chapter 6. This is the claim that not only is art ideological, but so, too, is the very way in which art is spoken and written about.

Chapter 6

Discourses on Art

In the preceding chapter, I reviewed the argument that the meanings signified by art are ideological in nature. In this chapter I take up a related argument that is also advanced in cultural studies. This is the argument that the ways in which we speak and write about art are also ideological. My examples are drawn from writings about the contemporary art of aboriginal peoples in Canada.

Contemporary Art by Aboriginal Peoples in Canada

A good starting point for this discussion is an examination of the ways in which aesthetic forms currently produced by aboriginal peoples in Canada are written about in certain newspaper accounts. As I have also argued elsewhere (with Ruth Phillips), often such accounts have represented these forms within a category of art called "Native Art" (or "Indian art" or "Inuit Art"), and often such accounts have treated this art as fundamentally and necessarily distinct from so-called "mainstream" or "contemporary" art by non-aboriginal Canadians (Blundell and Phillips 1983). Along with the prehistoric and historic aesthetic productions of Canada's aboriginal peoples, such forms are sometimes considered "ethnographic" or even "primitive" works of art.

One result of this way of conceptualizing contemporary aboriginal-produced art forms is that they are often written about

as though they are somehow an art that is more of the past than the present. So-called "Native Art" gets treated as though its history — if indeed it is even acknowledged to have a history — is a history that is distinct from the (Western) history of Western art (see also Price 1989). Therefore (and we saw in part how this situation has arisen in Chapter 2) contemporary art by aboriginal artists is often thought properly to belong in museums of anthropology rather than in institutions of fine art such as the National Gallery of Canada.

In fact, major public collections of art by aboriginal Canadians have been subject to confusing and overlapping mandates from government agencies. Much of what has been collected over the years is in ethnographic institutions such as the Canadian Museum of Civilization (formerly the National Museum of Man). Until recently, when it was turned over to various cultural institutions across the country, the Department of Indian Affairs had a large collection of aboriginal produced art which grew from economic incentive programs and the purchase of government office decorations. The National Gallery of Canada has only a small collection of works by the country's aboriginal artists, although it does exhibit contemporary Inuit-produced sculptures and graphics. However, as Dorothy Speak has argued, because these exhibits have been physically placed in a separate gallery within the National Gallery of Canada, what is perpetuated is "the perception that Inuit artists are essentially different from other Canadian artists [and that their art] must be appreciated and assessed within a special ethnographic context" (Speak 1988:6).

In point of fact, and as many recent studies clearly show, aesthetic forms by aboriginal Canadians do not merely "preserve" aesthetic styles and meanings from some prehistoric (and often romanticized) past. Instead, over the past several decades, there has been a surge of aesthetic activity on the part of aboriginal peoples in Canada. The results include a diversity of innovative forms that draw on alternative aesthetic sources, and often express meanings about contemporary life.

On the Northwest Coast, for example, an exciting "school" of graphic art draws upon the style and imagery of prehistoric

and historic Indian artifacts but also upon recently adopted media such as silk-screen printing (Hall Jr. et al. 1981). In Central Canada, Norval Morrisseau and other founders of the so-called contemporary "Woodland School" have combined graphic elements derived from earlier Indian cultural forms with the modernist conventions of European art (Blundell and Phillips 1983). In the Far North, Euro-Canadians introduced sculptural and graphic techniques to Inuit who now produce works in these media that are acclaimed internationally for their technical and aesthetic virtuosity (Graburn 1976a; Inuit Art Foundation 1990/91).

The contexts and purposes of these forms vary widely in Canada. Some are made for use by Indigenous peoples who live in aboriginal communities and link their art to goals of self-determination and cultural survival. Other forms are directed towards non-aboriginal audiences, including tourists, connoisseurs, and museums or galleries of art.

Among the producers of such contemporary art forms are individuals trained in cosmopolitan art schools who strive for recognition of the aesthetic quality of their work from an international audience. Such individuals may or may not live in aboriginal communities, and the content of their work may or may not have an explicit "native" reference. Often what their work does refer to is their personal experience of the contemporary world. For example, in a recent work, the Canadian artist of aboriginal ancestry, Carl Beam, juxtaposes his own image with (among others) those of a nuclear submarine and a dead whale. When he was asked what this imagery meant to him, Beam responded concisely, "That's my reality" (Beam 1988).

The Concept of Discourse

This brief overview of the contemporary art of aboriginal Canadians indicates that representing this art as somehow an art of the past is misleading at best. How is it, then, that such representational practices persist?

Changing Perspectives

Part of the answer to this question, I believe, is that false presumptions about the art of aboriginal Canadians are both encoded and decoded in the linguistic practices employed to speak and write about such art. Furthermore, I want to argue that these practices replicate linguistic practices that have been widespread in anthropology but have come under attack in recent years.

Such linguistic practices involve both individual speech acts and the production of larger, more enduring **texts**, such as newspaper and magazine accounts as well as scholarly analyses. Especially influenced by the work of Michel Foucault, such linguistic practices are conceptualized within cultural studies as forms of **discourse**. (For a readable discussion of Foucault's ideas, see White 1979.)

Discourses are regulated systems of statements through which knowledge is produced (so that knowledge, like other aspects of Culture, is also seen as socially constructed). Discourses are characterized by *rules* which delimit what can, or cannot, be said about a particular topic. Discourses also provide the concepts by which statements, including new ones, can be made.

Furthermore, because discursive practices are at the same time signifying practices, it is argued that our very perception of the world is mediated through discourse, in that the rules and concepts of a discourse mold the way we experience and understand reality. And, like other signifying practices, discursive practices arise in the context of specific, and variable, social conditions whose characteristics are themselves the legacy of prior historical practices and conditions.

As Turner writes:

> The development of the term *discourse* has itself been significant; it refers to socially produced groups of ideas or ways of thinking that can be tracked in individual texts or groups of texts, but that also demand to be located within wider historical and social structures or relations. (1990:32–33, emphasis in original)

Importantly, a discourse is never a direct expression of some transcendent, ahistorical reality. Instead, a discourse is *always*

a socially constructed version of that reality which may serve the self-interest of a particular society or group within a society. However, discourses often mask such self-interest when the rules and concepts they embody and the knowledge they generate are promulgated and experienced as the natural order of things. That is to say, like the meanings encoded or decoded in art forms, discourses are also, and always, ideological in nature (although they can be ideological in different ways), promoting views of the world that either promote or work against unequal social relations.

Many representations of contemporary art by aboriginal peoples in Canada are influenced by anthropology because (as was argued in Chapter 2) anthropology has been constructed in the West as the primary producer of knowledge about those non-Western peoples who were colonized by European nations, including the aboriginal peoples of post-colonial nations such as Canada. Therefore, when aboriginal Canadians are the subject at hand, concepts and ideas which have been most fully formulated and articulated by anthropologists are drawn upon by others.

That is to say, the representations of anthropology not only circulate among its own disciplinary membership, but they recur in the representations of other Western academic disciplines, including those of art historians writing about Indigenous art. They also influence portrayals of other peoples which appear in various forms of élite and popular culture. They inform government policies and programmes that are directed at non-Western peoples and ethnic or sub-cultural groups within the West. In particular, they influence representations found in the journalistic media.

Because anthropology has been constructed in the West as a privileged discourse about Indigenous peoples, and because anthropologists are often considered to be "experts" on Indigenous peoples, the media have turned to them and to their texts when Indigenous peoples, including their art, have been the topic at hand. For example, journalists not only reproduce the findings of anthropologists, but in many cases they do so while employing virtually the same discursive forms as anthropology. They

write of Indigenous Peoples as "traditional" and contrast them with "moderns," and they take as important questions those that are framed by the "experts."

Anthropologists and their texts thus constitute, in the words of Stuart Hall (another founder of cultural studies) "accredited sources" and "primary definers" of social phenomena regarding aboriginal peoples (Hall et al. 1978:57). In the case of the journalistic press, anthropological sources are consulted as journalists attempt to make sense of "news" regarding aboriginal peoples, with the consequence that anthropological representations of aboriginal peoples are sometimes reproduced in the media (Hall et al. 1978: Ch. 3; see also Hall 1980; and Hall et al. 1980).

Anthropological Discourse

If anthropologists and their texts have such influence in the wider society, then it is clearly important to consider challenges to the discipline's practices. As I indicated in the Introduction to this book, one of the most significant developments in anthropology over the past two decades has been a questioning of its own representational practices. One focus of these critiques is the way the temporality of others is represented.

To understand this particular critique, it is necessary to recall, as I have already discussed in Chapter 2, that anthropology emerged as Western nations were discovering and colonizing other peoples. As we saw, both the emergence of anthropology and the West's expansionistic colonialism took place at a time when notions of socio-cultural stages along an evolutionary progression dominated thinking about non-Western peoples. The societies that came to concern anthropology were those thought to represent stages of socio-cultural evolution through which Western society had already passed before its attainment of modernity. Such societies were named as "primitive" ones, and it was presumed that their ways of life belonged to a time distant from that of the Western anthropologist.

a socially constructed version of that reality which may serve the self-interest of a particular society or group within a society. However, discourses often mask such self-interest when the rules and concepts they embody and the knowledge they generate are promulgated and experienced as the natural order of things. That is to say, like the meanings encoded or decoded in art forms, discourses are also, and always, ideological in nature (although they can be ideological in different ways), promoting views of the world that either promote or work against unequal social relations.

Many representations of contemporary art by aboriginal peoples in Canada are influenced by anthropology because (as was argued in Chapter 2) anthropology has been constructed in the West as the primary producer of knowledge about those non-Western peoples who were colonized by European nations, including the aboriginal peoples of post-colonial nations such as Canada. Therefore, when aboriginal Canadians are the subject at hand, concepts and ideas which have been most fully formulated and articulated by anthropologists are drawn upon by others.

That is to say, the representations of anthropology not only circulate among its own disciplinary membership, but they recur in the representations of other Western academic disciplines, including those of art historians writing about Indigenous art. They also influence portrayals of other peoples which appear in various forms of élite and popular culture. They inform government policies and programmes that are directed at non-Western peoples and ethnic or sub-cultural groups within the West. In particular, they influence representations found in the journalistic media.

Because anthropology has been constructed in the West as a privileged discourse about Indigenous peoples, and because anthropologists are often considered to be "experts" on Indigenous peoples, the media have turned to them and to their texts when Indigenous peoples, including their art, have been the topic at hand. For example, journalists not only reproduce the findings of anthropologists, but in many cases they do so while employing virtually the same discursive forms as anthropology. They

write of Indigenous Peoples as "traditional" and contrast them with "moderns," and they take as important questions those that are framed by the "experts."

Anthropologists and their texts thus constitute, in the words of Stuart Hall (another founder of cultural studies) "accredited sources" and "primary definers" of social phenomena regarding aboriginal peoples (Hall et al. 1978:57). In the case of the journalistic press, anthropological sources are consulted as journalists attempt to make sense of "news" regarding aboriginal peoples, with the consequence that anthropological representations of aboriginal peoples are sometimes reproduced in the media (Hall et al. 1978: Ch. 3; see also Hall 1980; and Hall et al. 1980).

Anthropological Discourse

If anthropologists and their texts have such influence in the wider society, then it is clearly important to consider challenges to the discipline's practices. As I indicated in the Introduction to this book, one of the most significant developments in anthropology over the past two decades has been a questioning of its own representational practices. One focus of these critiques is the way the temporality of others is represented.

To understand this particular critique, it is necessary to recall, as I have already discussed in Chapter 2, that anthropology emerged as Western nations were discovering and colonizing other peoples. As we saw, both the emergence of anthropology and the West's expansionistic colonialism took place at a time when notions of socio-cultural stages along an evolutionary progression dominated thinking about non-Western peoples. The societies that came to concern anthropology were those thought to represent stages of socio-cultural evolution through which Western society had already passed before its attainment of modernity. Such societies were named as "primitive" ones, and it was presumed that their ways of life belonged to a time distant from that of the Western anthropologist.

As Johannes Fabian has argued in his important book *Time and the Other: How Anthropology Makes its Object* (1983), this "temporal distancing" of these others became "spatialized" in that it was people living in those areas of the world remote from the centers of European civilization that were constructed (and named) as "primitives."

Anthropologists of the early 20th century repudiated such evolutionary presumptions. Nonetheless, as recent critical anthropologists have argued, some ethnographic accounts, particularly those informed by Functionalism, have continued to represent the Cultures studied by anthropology in a "pure" form that has filtered out the effects of contact with Western colonizing societies. In some cases, it is as though researchers have been trying to see and record these Cultures, not as they exist in the 20th century, but as they would have been before the arrival of outsiders. As a result of this particular perspective, the reports of many 20th century anthropologists have tended to acknowledge historical time in only a rhetorical way, by situating others as living either just before of just after contact with the West — such contact often thought of as "the deluge" (Marcus and Fischer 1986:95; Marcus 1986:165, n. 1).

Some writers have employed what Marcus calls a "**salvage mode**" of writing, whereby they claim that their observations constitute a last chance to portray a Culture before it is engulfed by modernity; others have employed what Marcus refers to as a "**redemptive mode**" to represent what are conceptualized as the "authentic" aspects of a Culture, now existing only as remnants from a past, "pure" period that preceded the Culture's contact with the West (Marcus 1986:165, n. 1). When one of these modes has been employed, the time of the other has been the infamous **ethnographic present**, an eternalized past-in-the-present which locates others in a time-order presumed to be somehow different from that of the anthropologist (Pratt 1986:33) and inscribes their Cultures as static (until, of course, contact, after which they survive only as dying remnants of their prior so-called "authentic" forms).

Changing Perspectives

For many contemporary anthropologists, then, these sorts of representational practices in anthropological texts are highly problematic. Critical anthropologists argue that the anthropologist and the people s/he "studies" are of course living at the same time, and, furthermore, that such people do not live (and probably never have lived) in a static, unchanging world (see Clifford 1988). As is now widely acknowledged, the social, political, economic, and ideological processes of the contemporary world profoundly affect them just as they do all the other peoples of an increasingly interconnected world. As Marcus and Fischer have put it, such "outside" forces for any group are "an integral part of the construction and constitution of the 'inside' of the cultural unit itself" (1986:77).

Despite these critiques from within anthropology, critics argue that problematic practices persist. Sometimes in writing about non-Western peoples, including writing about their art, cultural forms considered to be post-contact by anthropologists have not been mentioned or they have been devalued by reference to their own so-called "authentic" but "dying" ones.

Fabian (1983) has considered why it is that such temporal presumptions sometimes persist in contemporary anthropology and in other accounts that are influenced by anthropological discourse. He argues that although a maturing anthropology repudiated evolutionism, the temporal presumptions which it helped to establish persist in new guises in its discourse. The term "primitive" is now used less frequently, but according to Fabian the conceptual category it designates persists with a spate of substitute labels, such as "traditional," "tribal," "preliterate," and so forth.

Some anthropologists interested in art have explicitly rejected the term, and the category, "primitive art" (e.g., Layton 1981). In response to critiques directed at his use of this term, another author of a widely used textbook on anthropological studies of art has changed its title from *Art in Primitive Societies* to *Art in Small-Scale Societies* (Anderson 1989).

Nonetheless, as Fabian has argued, like the term "primitive," these substitute terms also embody time-distancing presumptions. Such substitute terms have been applied to people

who have been contrasted, discursively, with peoples — invariably Western ones — who are represented as "modern" or "developed." As Fabian puts it, by means of these terms, anthropology has continued to treat what is essentially a temporal category of thought as an object of thought.

Indeed, Fabian continues that new theories of modernization and development which crystallized in anthropology and other social sciences in the post-World War II period oppose tradition and modernity in what is in effect a reformulation of the stage progressions of earlier 19th century evolutionism. Such presumptions, Fabian argues, legitimate the domination of others through their denial that other societies share the same time as the West. This "denial of coevalness," as he calls it, serves to mask the true nature of conflict between Western nations and other peoples whom they have subordinated. The true nature of this conflict is the problematic simultaneity of different, conflicting, and contradictory forms of consciousness. As Fabian writes:

> Tradition and modernity are not "opposed" (except semiotically), nor are they in "conflict." All this is (bad) metaphorical talk. What are opposed in conflict ... are not the same societies at different stages of development, but different societies facing each other at the same time. (1983:155)

Representing Powwows in the Journalistic Media

Let me return to the writings about contemporary art by aboriginal people in Canada and provide some examples of how this art is represented discursively. I want to argue here that some discursive practices employed to write about aboriginal produced art forms encode the same temporal presumptions about aboriginal peoples that have been identified by Fabian and others in anthropological discourse.

Consider, for example, the case of events called powwows which are put on by aboriginal peoples across Canada. These events involve competitive dancing (for monetary prizes) by per-

formers who wear elaborate outfits and dance to the accompaniment of drumming and singing. The expressive forms of contemporary powwows derive from earlier aboriginal traditions and from the dominant Euro-Canadian culture. Like other contemporary aboriginal-produced aesthetic productions, powwows are also highly innovative in nature.

Such powwows are in fact relatively recent in Canada, first appearing in the post-World War II period. As I have argued elsewhere, their expressive forms not only celebrate aboriginal identities, but powwows are sites/sights where the various meanings that characterize contemporary aboriginal identities are signified, challenged, and negotiated (see Blundell 1985/86, 1989b and 1993a for further discussion of the significations of powwows).

For example, the role of aboriginal Canadians in the wider society has for years been signified (and its meaning negotiated) at powwows through forms of dress and through special dances that honor Indian veterans of Canada's national wars. Thus the powwows that I attended throughout the 1980s began with aboriginal veterans leading the "Grand Entry" of dancers onto the powwow grounds while parading the Canadian flag. (When dancers from the United States were present, the American flag was also carried.)

Signs like the national flag (and the military insignia of uniforms which some aboriginal veterans have also worn) derive from the wider, and the dominant, culture. These signs both reflect and recall a range of actions and attitudes that aboriginal people have adopted in their attempts to survive under conditions that have often been oppressive. The explicit purpose of these veteran flag bearers, and of powwow organizers who recruit them, has been to honor the actions of aboriginal soldiers in Canada's foreign wars.

This intent — aesthetically expressed as it is — reflects a strategy whereby some aboriginal people have participated in national institutions such as the military in order to enhance their claims for employment, prestige, and other rewards available in the wider society. Given their subordinate position within Canada,

symbolic expressions of national patriotism, such as those that have occurred at powwows, also provide an ideological basis for aboriginal access to Canada's dominant political discourse. That is, some aboriginal individuals have attempted to legitimate their claims for better treatment through these reminders of their commitment to nationalistic values.

The ways in which meanings about aboriginal veterans have been signified at powwows changed quite abruptly, however, at certain Ontario powwows during the summer of 1991. This of course was the first summer after the 1990 armed confrontation between Mohawk and Canada's armed forces at Oka (Kanasatake) and Kahnawake in Quebec. While pre-1991 powwows had included aboriginal veterans carrying the Canadian national flag, at some Ontario powwows in 1991 the national flag was either absent or its form was modified to incorporate an image of an aboriginal person.

These flags, which many aboriginal people refer to as "Indian Joe flags," promote alternative meanings about Indigenous Peoples in Canada. One promoted "message" of this "alternative" flag is that aboriginal people want a different relationship between their own "First Nations" and the Canadian state, viz., a relationship in which they have their own self-governments. This, of course, was a central theme for the aboriginal protesters at Oka, but one that had been forcibly challenged by the Canadian state.

This example of the changing signs of powwows indicates that powwows are highly dynamic sights where meanings about the place of aboriginal people in Canada are being signified. Nonetheless, the journalistic media often depict powwows as forms of the past. For example, consider a newspaper report from The Ottawa Citizen on May 31st, 1982. A front page photograph depicts a young costumed dancer drinking a bottled soft drink. The caption tells us that the young man "takes a quick slurp of a 20th century drink that looks out of place with his authentic native headdress, beads and fringe." We are thus led to the idea that Indians and their art forms are not only "old," but they are "out of place," that is anachronistic, in the modern world.

89

Consider as a further example a report which appeared in *The Ottawa Citizen* on July 7th, 1986. The report includes a photograph of a dancer holding a radio. The text beneath the photo inscribes the dancer's outfit as both old and "traditional," while the music on the radio is said to be "new" (see Blundell 1989a, Fig. 2). This report thus temporalizes both the powwow itself and the concept of tradition.

The idea that powwows are ancient cultural forms is also promoted in a recent article in the travel club magazine of the Canadian Automobile Association *Leisureways*. The author of this article begins with the following description of contemporary powwows in Canada:

> The insistent heartbeat of the drums sends shivers down the spine as the "dreamers" dip and sway in a stately ritual evoking ancient times. Clad in the traditional attire of their ancestors, they solemnly execute steps passed down for generations. They are pow wow dancers taking part in a spectacle which is partly religious and partly a social celebration of their Indian heritage. (Poole 1992:14)

Nowhere in this article is reference made to the distinct and changing history of powwows in Canada, or to the innovative nature of its expressive forms. Instead, this text reduces the contemporary powwow to a static, homogeneous, and timeless Indian "heritage" form.

The Discourse on Authenticity

This latter example indicates a further way in which time-distancing presumptions occur in media representations of contemporary art by aboriginal Canadians. This has to do with media concerns about the authenticity of so-called "native art." Media reviews often inscribe such art as authentic, and in most cases they praise it; or they question whether it is indeed authentic, and, if not, discredit it. Indeed, contemporary art by aboriginal Canadians is commonly advertised and marketed as authentic (or genuine) native art; the Canadian government even attaches tags to

certain aboriginal-produced art forms certifying their "authenticity" (see Blundell 1993b, 1994). In contrast to fine art forms produced by non-aboriginal artists, references to the authenticity (or lack thereof) of this art continue to be more common then are references to its aesthetic characteristics or quality.

My argument here is that when the media considers the authenticity of so-called "native art," authenticity itself becomes conceptualized in an essentially temporalized way. This occurs because what is addressed is the authenticity of an art form that is already encoded as an art of another time through time-distancing terms such as "primitive," or "tribal," or "traditional." Such discursive practices link the term "authenticity" with a term such as "primitive," "tribal," or "traditional," which is itself time-distancing in nature (according to semiotic theory the two linked terms are related **syntagmatically**). What is asked, either explicitly or implicitly, is not " Is this art authentic?" but rather " Is this authentic traditional art?" And authentic traditional art is presumed to be an art that derives from and/or expresses some past aesthetic convention and/or symbolic meaning. The art of the present is evaluated in the (presumed) terms of the past.

Such a way of writing (or speaking) is not unlike anthropology's redemptive mode, which we have seen has come under recent attack. Just as the anthropologist has filtered out the influences of the present to redeem and thus represent a past Culture, so the contemporary aboriginal artist is inscribed by the media as filtering out the influences of his or her own present and redeeming an art of the past.

This question about the authenticity of contemporary works by aboriginal artists is, therefore, a false and mystifying one that has been facilitated by inappropriate discursive practices. (In Barthes' sense, asking this question constitutes mythification.) This question is asked because the concept of authenticity is temporalized; it is asked because it is presumed that the only truly aboriginal art is so-called "traditional" art. It is presumed that art which is not recognizably traditional is not authentic, but the art of an assimilated person who has lost his or her sense of aboriginal identity.

Changing Perspectives

In framing the question regarding authenticity in this way, media critics, perhaps inadvertently, exacerbate the double bind in which many contemporary aboriginal artists find themselves. If they produce art forms that are "native looking" in style or content, their works are likely to be collected as ethnographic specimens and not treated seriously as art (and they may thus also reinforce the view that they are surviving primitives.) However, if they produce art in more recognizable modernist styles, they may not be considered authentic works of aboriginal art, and the institutions that presently collect art by aboriginal peoples in Canada may reject them.

Such a discursively constructed conceptualization of authenticity is clearly ideological. It forecloses discussions of the diverse sources which contemporary aboriginal artists draw upon, including not only those of earlier aboriginal parent Cultures but other Cultures as well. Such concepts mystify aboriginal revitalization and self-determination efforts whereby aboriginal peoples look selectively to values and behaviors that have their source in earlier aboriginal Cultures, not because they wish to return to a past way of life, but because they are attempting to construct more satisfying social and political forms for living in the contemporary world and articulating with the dominant non-aboriginal élite in Canada.

Furthermore, such conceptualizations elide aboriginal history, allowing only two alternatives: either aboriginal peoples conform to an earlier way of life, or they assimilate into the dominant (Western) one (cf. Berger 1979). Finally, the authenticity debate imposes on aboriginal peoples a truly repressive, and oppressive, conceptualization of aboriginal identity; aboriginal artists are not only told what kind of art to produce, but they are told that they are not "real" Indians, or Inuit, or Métis, if they produce another sort of art.

These concerns in the media about the authenticity of contemporary aboriginal art echo concerns expressed by some anthropologists as well as art historians of "Native Art." For example, great emotion has surrounded the question of whether contemporary Inuit-produced soapstone sculptures and graphic

forms are authentic, given that it is generally acknowledged that production and marketing techniques were introduced to the Canadian north in the mid-1900s and that Euro-Canadian mediators have influenced their form and content (Graburn 1976a). But interestingly, some anthropologists have debated the authenticity of contemporary Inuit art by resorting to arguments framed in the redemptive mode that I noted above.

For example, Edmund Carpenter has argued that Inuit carvings are not real (i.e., authentic) Inuit art because of the interventions of non-Inuit (Carpenter 1973:194–95). (They are post-"deluge.") In response, Nelson Graburn has argued that the carving practices of Inuit are "charged, male, socio-sexual activities that have a direct continuity with their former lives as hunters" (Graburn 1976a:55). His approach is framed within a redemptive mode in that he legitimates these carvings as authentic by arguing that they do embody cultural ideas with sources in the earlier, so-called "traditional" life of the Inuit that are preserved into the present day. I am not contesting the argument that such concepts are encoded in Inuit aesthetic practices — that they seem to be is an important insight by Graburn — but, rather, the fact that it seems necessary for some writers to identify the encoding of such concepts from the past before forms can be taken as authentically Inuit works of art.

Summary: Transforming Anthropological Discourse

The ways in which anthropologists or others speak or write about art is ideological nature. Discursive practices reproduce a particular way of thinking about the world and, as the examples given in this chapter indicate, such practices can naturalize a way of thinking that works to keep some individuals in subordinated roles.

But discursive practices can also construct new ways of understanding art, and this clearly is the challenge today for those of us writing about art. Elsewhere (Blundell 1989a, 1993b) I have

referred to such practices as **transformative practices**, and I have called for ways of writing about contemporary art by aboriginal Canadians that de-temporalize the term "tradition" so that preconceived ideas about art and identity are not inadvertently imposed upon individuals of aboriginal ancestry.

What this more critical perspective on discourse suggests is that we need a language in the anthropology of art that can acknowledge the histories of transformation in aboriginal communities and the dynamic nature of the forms by which their members wish to be distinguished. We need discursive practices that can reflect the way in which traditions, including aesthetic ones, are always *processes* of cultural "reproduction in action" (Williams 1981:187), rather than transcendent forms frozen in time.

Above all, we need discursive strategies that will de-temporalize the notion of authenticity as it has sometimes been applied to contemporary productions by aboriginal artists. Such strategies can work against the evaluation and legitimization of these art forms solely on the basis of their link to an (often romanticized) past.

Conclusions

Changing Perspectives on the Art of Canada's First Peoples

As we enter the 21st century, anthropology's interest in art has been influenced by changing perspectives within the discipline as well as by approaches advanced in related fields such as cultural studies. In this book, I have considered how these developments provide new ways of understanding art.

The influence of these developments is now seen in a growing body of scholarly work, not only in anthropology and cultural studies but also in new forms of art history (see, for example, Phillips 1994; Berlo and Phillips 1995). For example, many analysts take up the pivotal role of art in the politics of signification and in other processes of cultural politics in today's capitalist nation states. Nowhere is this more evident than in the case of writings about the expressive cultural forms of Canada's First Peoples (see, for example, Townsend-Gault 1992; Houle 1992; Nemiroff 1992; Ryan 1992; Lidchi 1997; McLoughlin 1993; and articles in Bennett and Blundell eds. 1995). These studies reveal that the sites/sights of aboriginal cultural politics have ranged from anthropological texts, to museum exhibits, to tourist attractions, to the representations of art in the media.

New perspectives have also encouraged new practices. In the case of Canada, new discursive strategies are now being deployed. Some continue with terms such as "Native art," "Indian art," or "Inuit art," but work to "empty" these linguistic "signs" of their stereotypical connotations (as, for example, the idea that Native art is an unchanged art of the past) and "reinvest" them with meanings that empower Indigenous artists. These discur-

sive strategies aim to change language in order to change people's perceptions and, in the process, overturn problematic stereotypes. If successful, such strategies have the potential to alter more problematic "decodings" of representations found in a wide range of textual forms.

More politically charged is the emergence of the term "First Nations art," now widely advanced to contest the hitherto marginal status of works by Indigenous Peoples within the so-called "mainstream" of Canadian art (see Houle and Podedworny 1994: 69). The less politically loaded term "First Peoples" is also increasingly used.

An alternative strategy provides greater terminological specificity, and thus attempts to re-form monolithic Native stereotypes, as in designations such as "Cree artist," "Haida artist," or "Métis artist" (Houle and Podedworny 1994:72). Of course, all three of these strategies may be employed in a single text, and, furthermore, the choice of strategy will likely be affected by the context of the text and its intended audience.

There have also been changes in the practices of public institutions that collect and exhibit art produced by First Peoples. In the case of museum exhibits of aboriginal artifacts and art forms, it is now clear that the 1988 exhibit *The Spirit Sings: Artistic Traditions of Canada's First Peoples* was a watershed for relations between First Nations artists and those of us who work in Canada as anthropologists, art historians and museum curators. While many had agreed that changes were required, as the Mohawk artist and Director of the Woodland Cultural Centre Museum in Brantford, Ontario, Tom Hill points out *The Spirit Sings* brought the issue of presentation of First Nations art and heritage into focus on both a national and international level" (1994:40).

Mounted for the 1988 Winter Olympics in Calgary, this exhibit of historic Indian cultural forms became a site/sight of cultural politics when it was criticized not only because of its corporate sponsorship and the limited role of First Peoples in its organization, but because its celebration of the past obscured both the nature of contemporary aboriginal cultural forms and current relations between First Peoples and the Canadian state

Conclusions

(see Ames 1992:160–62; Myers 1988; Blundell and Grant 1989; Phillips 1990).

In the wake of the controversy stirred up by this exhibit, a national conference brought together First Peoples, anthropologists, art-historians and museum workers to address First Peoples' concerns, and also led to the formation of a task force to consider how relations between First Peoples and museums could be improved. Chaired by Tom Hill and Royal Ontario Museum anthropologist Trudy Nicks, the task force report of 1992 made more than thirty recommendations including a call for greater involvement of First Peoples in the programming activities of public museums and galleries and more say for them in the interpretation of their cultures (Assembly of First Nations and Canadian Museums Association 1992; see also Hill and Nicks 1992; and Hill 1994).

Another important initiative in the early 1990s was the "Mandate Study" of the Thunder Bay Art Gallery (Thunder Bay Art Gallery 1994). This study was organized by Saulteaux artist and writer Robert Houle and art historian Carol Podedworny. A detailed questionnaire was employed to obtain input from aboriginal artists and both aboriginal and non-aboriginal academics and cultural workers on a range of issues regarding the exhibition, collection, and interpretation of contemporary art by First Peoples.

Also in the early 1990s, Lee-Ann Martin's report for the Canada Council on "the politics of inclusion and exclusion" with regard to "contemporary Native Art and public art museums in Canada" was a further attempt to respond to critiques of the policies and practices of state cultural institutions (Martin 1991).

Many observers now see a new era of cooperation between First Peoples and public museums and galleries, as well as more sensitivity on the part of non-aboriginal people who speak and write about First Nations art.

In my view, one of the most significant developments over the past decade has been a proliferation of accounts by aboriginal artists and scholars, whose representations of First Nations art appear in exhibition catalogues and in a wide range of scholarly

and popular journals (for example, Houle 1992; essays by aboriginal artists in McMaster and Martin 1992; artists' statements in Nemiroff et al. eds; and Valaskakis 1993a, 1993b, 1993c) The Inuit-owned Inuit Art Foundation has been a leader in giving voice to Indigenous artists through its interviews of Inuit artists in its journal *Inuit Art Quarterly*.

Many of these accounts by aboriginal artists situate art within its historical and contemporary contexts and, in this way, provide powerful challenges to more conventional views. For example, in his writings, Cree artist, museum curator, and anthropologist Gerald McMaster notes how political events in Canada in the early 1990s have affected the production and reception of First Nations art. For him, Elija Harper's role in challenging the Meech Lake Accord and, in particular, the events of Oka have not only brought aboriginal issues into wide public view, but these events have further politicized First Nations artists who have "seized the moment by participating in several exhibitions that demonstrated their solidarity with Native political leaders and with those manning the barricades at Oka" (McMaster 1994:16).

Changes in the wider cultural arena have also encouraged transformations in the way that First Nations art is treated. Observers point to a shift in the art world from modernism to postmodernism. According to Diana Nemiroff, the National Gallery of Canada's curator of Contemporary Art, there has been a "breaking down of institutional canons, an emphasis on pluralism, and an interest in exploring questions of difference, and [this has] weakened the ethnocentrism of the art establishment;" as a result there has been a "dramatic increase in the number of exhibitions of contemporary First Nations art, organized from a variety of perspectives" (Nemiroff 1992:35–36).

Robert Houle and Carol Podedworny, organizers of the Thunder Bay Art Gallery's Mandate Study, also report that there is now less pressure on First Nations artists to conform to a European artistic hegemony in order to have their productions valued as part of so-called "mainstream" art (Houle and Podedworny 1994:71).

Conclusions

Within this new climate, innovative exhibits of First Nations art have been curated or co-curated by First Peoples, and these, too, have worked to transform perceptions about aboriginal-produced art as well as engendering new relations between First Peoples and public museums and galleries. For example, *Indigena: Contemporary Native Perspectives* opened in 1992 at the Canadian Museum of Civilization. This exhibit, which included the works of visual, literary and performing artists, was presented as a "de-celebration" of the 500th anniversary of the so-called "discovery" by Columbus of the "New World" (McMaster and Martin 1992).

Another landmark exhibit, also held in 1992, was *Land, Spirit, Power: First Nations at the National Gallery of Canada*, curated by aboriginal and non-aboriginal curators (Nemiroff et al. 1992). One of its curators, Charlotte Townsend-Gault, noted that this exhibit brought "artists of aboriginal ancestry into an institution which, both literally and symbolically, encapsulates the Eurocentric nature of Canada's national culture" (1995:92).

This is not to say that problematic depictions of art by First Peoples have disappeared, or that exhibits such as *Indigena* and *Land, Spirit, Power* are now the norm. While there are encouraging shifts in the ways in which Indigenous arts are analyzed, written about and exhibited, clearly there remains much to be done. As Tom Hill (1994:43) has written with regard to the recommendations of the Task Force on Museums and First Peoples: "I feel we have now set out our common vision. In a true sense, we have become 'allies.' We must now demonstrate our 'potential.'"

— what about economics? private co's use of FN art.

Changing Perspectives

Bibliography

Alland, Alexander, Jr.

1977 *The Artistic Animal: An Inquiry Into the Biological Roots of Art.* New York: Columbia University Press.

Ames, Michael M.

1985 *Museums, The Public and Anthropology: A Study in the Anthropology of Anthropology.* Vancouver: University of British Columbia Press.

1992 *Cannibal Tours and Glass Boxes: The Anthropology of Museums.* Vancouver: University of British Columbia Press.

Anderson, Richard L.

1989 *Art in Small-Scale Societies.* Englewood Cliffs: Prentice-Hall. [orig. 1979]

Assembly of First Nations and Canadian Museums Association

1992 *Report of the Task Force on Museums and First Peoples.* Ottawa: Assembly of First Nations and Canadian Museums Association.

Barrett, Stanley R.

1996 *Anthropology: A Student's Guide to Theory and Method.* Toronto: University of Toronto Press.

Barthes, Roland

1973 *Mythologies.* Selected and trans. by Annette Lavers. London: Granada. [orig. 1957]

Beam, Carl

1988 "Art and Politics." Presentation at the Conference "Four Nations: Towards Awareness and Understanding," September 29–October 2. Sponsored by Canadian Student Pugwash. Ottawa: Carleton University.

Bennett, Tony

1995 *The Birth of the Museum: History, Theory, Politics*. London and New York: Routledge.

Bennett, Tony, Graham Martin, Colin Mercer and Janet Woollacott

1981 "Antonio Gramsci." In *Culture, Ideology and Social Process*, Tony Bennett, Graham Martin, Colin Mercer and Janet Woollacott (eds.). London: Open University, 191–218.

Bennett, Tony and Valda Blundell (eds.)

1995 *First Peoples: Cultures, Policies, Politics. Cultural Studies* (special issue) 9(1).

Berger, The Honourable Mr. Justice T.R.

1979 "Native Rights in the New World: A Glance at History." In *Papers from the Sixth Annual Congress of the Canadian Ethnology Society*. Canadian Ethnology Service Paper Number 78. Ottawa: National Museum of Man Mercury Series, National Museums of Canada, 1–27.

Berger, John

1972 *Ways of Seeing*. London: Penguin.

Berlo, Janet Catherine and Ruth B. Phillips

1995 "The Problematics of Collecting and Display, Part I. *Art Bulletin* LXXVII(1), March.

Bloch, Maurice

1983 *Marxism and Anthropology*. Oxford: Oxford University Press.

Blundell, Valda

1985/86 "Une approche sémiologique du powwow canadien contemporain." *Recherches amérindiennes au Québec* XV(4) Hiver:53–66.

1989a "Speaking the Art of Canada's Native Peoples: Anthropological Discourse and the Media." *Australian-Canadian Studies* 7(1–2):23–44.

1989b The Tourist and the Native." In *A Different Drummer: Readings in Anthropology with a Canadian Perspective*, Bruce Alden Cox, Jacques Chevalier, and Valda Blundell (eds). Ottawa: Carleton University Press and The Anthropology Caucus, Carleton University, 49–62.

Bibliography

1992 *New Directions in the Anthropological Study of Art.* Ottawa: Carleton University Press, Manuals, Casebooks and Special Projects Division.

1993a "Echoes of a Proud Nation: Reading the Kahnawake Powwow as a Post-Oka Text." *Canadian Journal of Communications* 18(3):333–50.

1993b "Aboriginal Empowerment and Souvenir Trade in Canada." *Annals of Tourism Research* 20(1):64–87.

1994 "'Take Home Canada': Representations of Aboriginal Canadians as Tourist Souvenirs." In *The Socialness of Things: Essays on the Socio-Semiotics of Objects*, Stephen Harold Riggins (ed.). Berlin and New York: Mouton de Gruyter, 251–84.

1995-96 "Riding the Polar Bear Express: And Other Encounters Between Tourists and First Peoples in Canada." *Journal of Canadian Studies* 30(4), Winter:28–51.

Blundell, Valda and Laurence Grant

1989 "Preserving Our Heritage: Getting Beyond Boycotts and Demonstrations." *Inuit Art Quarterly* 4(2):12–16.

Blundell, Valda and Ruth Phillips

1983 "If it's Not Shamanic, Is it Sham? An Examination of Media Responses to Woodland School Art." *Anthropologica* n.s., 25(1):117–32.

Blundell, Valda, John Shepherd and Ian Taylor (eds.)

1993 *Relocating Cultural Studies: Directions in Theory and Research.* London: Routledge.

Boas, Franz

1927 *Primitive Art.* Oslo: Aschehoug.

Bruck, Peter, Ian Taylor, Valda Blundell and Ruth Phillips

1986 *Archaeology and the Canadian Publics.* A Report Prepared for the Department of Communications, Ottawa.

Carpenter, Edmund

1973 *Eskimo Realities.* New York: Holt, Rinehart and Winston.

Clifford, James

1988 *The Predicament of Culture: Twentieth-Century Ethnography, Literature, and Art.* Cambridge, Mass.: Harvard University Press.

103

Changing Perspectives

1991 "Four Northwest Coast Museums: Travel Reflections." In *Exhibiting Cultures: The Poetics and Politics of Museum Display*, Ivan Karp and Steven D. Lavine (eds). Washington, D.C.: Smithsonian Institution Press, 212-54.

Clifford, James and George F. Marcus (eds).

1986 *Writing Culture: The Poetics and Politics of Ethnography*. Berkeley: University of California Press.

Cole, Douglas

1985 *Captured Heritage: The Scramble for Northwest Coast Artifacts*. Toronto: Douglas and McIntyre.

Cole, Sally and Lynne Phillips

1995 *Ethnographic Feminisms: Essays in Anthropology*. Ottawa: Carleton University Press.

Cohen, Abner

1974 *Two-Dimensional Man*. Berkeley: University of California Press.

Coombe, Rosemary J.

1991a "Encountering the Postmodern: New Directions in Cultural Anthropology." *The Canadian Review of Sociology and Anthropology* 28(2), May:188-205.

1991b "Beyond Modernity's Meanings: Engaging the Postmodern in Cultural Anthropology." *Culture* XI(1-2):111-24.

Eagleton, Terry

1976 *Criticism and Ideology*. London: New Left Books.

Fabian, Johannes

1983 *Time and the Other: How Anthropology Makes Its Object*. New York: Columbia University Press.

Geertz, Clifford

1973 *The Interpretation of Cultures*. New York: Basic Books.

1976 "Art as a Cultural System." *Modern Language Notes* 91:1473-99.

Goldwater, Robert

1938 *Primitivism in Modern Art*. New York: Random House.

Bibliography

Graburn, Nelson

1976a "Eskimo Art: The Eastern Canadian Arctic." In Graburn (ed.), 39-55.

1976b "Introduction: Arts of the Fourth World." In Graburn (ed.), 1-32.

Graburn, Nelson (ed.)

1976 *Ethnic and Tourist Arts: Cultural Expressions from the Fourth World.* Berkeley: University of California Press.

Hadjinicolaou, Nicos

1978 *Art History and Class Struggle.* London: Pluto.

Hall, Edwin S. Jr., Margaret B. Blackman and Vincent Rickard

1981 *Northwest Coast Indian Graphics: An Introduction to Silk Screen Prints.* Vancouver: Douglas and McIntyre.

Hall, Stuart

1980 "Encoding/Decoding" In Hall et al. (eds.), 128-38.

Hall, Stuart, Chas Critcher, Tony Jefferson, John Clarke and Brian Roberts

1978 *Policing the Crisis: Mugging, the State, and Law and Order* London: Macmillan Press (chap. 3, "The Social Production of News").

Hall, Stuart, Dorothy Hobson, Andrew Lowe, and Paul Willis (eds.)

1980 *Culture, Media, Language.* London: Hutchinson.

Hawkes, Terrence

1977 *Structuralism and Semiotics.* London: Methuen.

Heck, Marina Camargo

1980 "The Ideological Dimension of Media Messages." In Hall et al. (eds.), 122-27.

Hill, Tom

1994 "Between Two Potentially Strong Allies." In Thunder Bay Art Gallery 1994:40-44.

Hill, Tom and Trudy Nicks

1992 "Turning the Page: Forging New Partnerships Between Museums and First Peoples." In Assembly of First Nations and Canadian Museum of Civilization, 1992.

Houle, Robert

1992 "The Spiritual Legacy of the Ancient Ones." In Nemiroff et al., 43–74.

Houle, Robert and Carol Podedworny

1994 "Thunder Bay Art Gallery Mandate Study: Analysis of the Questionnaire." In Thunder Bay Art Gallery 1994:69–75.

Hutcheon, Linda

1988 *A Poetics of Postmodernism: History, Theory, Fiction.* New York: Routledge.

Hymes, Dell (ed.)

1969 *Reinventing Anthropology.* New York: Pantheon Books.

Inuit Art Foundation

1990/91 *Inuit Art World. Inuit Art Quarterly* (special issue), 5(4).

Johnson, Richard

1986/87 "What is Cultural Studies Anyway?" *Social Text: Theory/Culture/Ideology* 16 (Winter):38–80.

Jurmain, Robert, Harry Nelson and William A. Turnbaugh

1987 *Understanding Physical Anthropology and Archaeology*, 3rd ed. New York: West.

Kuper, Adam

1988 *The Invention of Primitive Society. Transformations of an Illusion.* London: Routledge.

Layton, Robert

1981 *The Anthropology of Art.* London: Granada.

Lidchi, Henri

1997 "The Poetics and the Politics of Exhibiting Other Cultures." In *Representation: Cultural Representations and Signifying Practices*, Stuart Hall (ed.). London: Sage, 157–222.

Maquet, Jacques

1971 *Introduction to Aesthetic Anthropology.* A McCaleb Module in Anthropology.

1986 *The Aesthetic Experience: An Anthropologist Looks at the Visual Arts.* New Haven and London: Yale University Press.

Bibliography

Marcus, George E.

1986 "Contemporary Problems of Enthnography in the Modern World System." In Clifford and Marcus (eds.), 165-93.

Marcus, George E. and Michael M.J. Fisher

1986 *Anthropology as Cultural Critique: An Experimental Moment in the Human Sciences.* Chicago: University of Chicago Press.

Martin, Lee-Ann

1991 *The Politics of Inclusion and Exclusion: Contemporary Native Art and Public Art Museums in Canada.* Report submitted to the Canada Council, Ottawa.

Matejka, Ladislav and Irwin R. Titunik (eds.)

1976 *Semiotics of Art.* Cambridge: MIT Press.

M'Closkey, Kathy

1994 "Marketing Multiple Myths: The Hidden History of Navajo Weaving." *Journal of the Southwest* 36(3):185-220.

McLoughlin, Moira

1993 "Of Boundaries and Borders: First Nations' History in Museums." *Canadian Journal of Communication* 18(3):365-85.

McMaster, Gerald

1994 "The Politics of Canadian Native Art." In Thunder Bay Art Gallery 1994:7-19.

McMaster, Gerald and Lee-Ann Martin

1992 *Indigena: Contemporary Native Perspectives.* Hull, Quebec: Canadian Museum of Civilization and Vancouver/Toronto: Douglas and McIntyre.

Mukarovsky, Jan

1976a "Art as Semiotic Fact." In Matejka and Titunik (eds.), 3-9.

1976b "The Essence of the Visual Arts." In Matejka and Titunik (eds.), 229-44.

Myers (Mitchell), Marybelle

1988 "The Glenbow Affair." *Inuit Art Quarterly* Winter 3(1):12-16.

Nemiroff, Diana

1992 "Modernism, Nationalism, and Beyond: A Critical History of Exhibitions of First Nations Art." In Nemiroff et al. (eds.), 15-42.

107

Nemiroff, Diana, Robert Houle and Charlotte Townsend-Gault (eds.)

1992 *Land, Spirit, Power: First Nations At the National Gallery of Canada*. Ottawa: National Gallery of Canada.

Parker, Rozika and Griselda Pollock

1981 *Old Mistresses: Women, Art and Ideology*. New York: Pantheon.

Phillips, Ruth B.

1990 "The Public Relations Wrap." *Inuit Art Quarterly*, Spring 5(2): 13-21.

1994 "Fielding Culture: Dialogues Between Art History and Anthropology." *Museum Anthropology* 18(1):39-46.

Pollock, Griselda

1988 *Vision and Difference: Femininity, Feminism and the Histories of Art*. London: Routledge.

Poole, Bonny

1992 "North American Dreamers." *Leisureways*, April:14-18.

Pratt, Mary Louise

1986 "Fieldwork in Common Place." In Clifford and Marcus (eds.), 27-50.

Price, Sally

1989 *Primitive Art in Civilized Places*. Chicago: University of Chicago Press.

Ryan, Allan J.

1992 "Postmodern Parody: A Political Strategy in Contemporary Canadian Native Art." *Art Journal*, Fall:59-65.

Sass, Louis A.

1986 "Anthropology's Native Problems: Revisionism in the Field." *Harper's Magazine* (May):49-57.

Saussure, Ferdinand de

1960 *Course in General Linguistics*, translated by Wade Baskin. London: Peter Owen.

Shepherd, John

1991 *Music as Social Text*. Cambridge: Polity Press.

Bibliography

1993 "Value and Power in Music: An English Canadian Perspective." In Blundell et al. (eds.), 171–206.

Silver, Harry R.

1979 "Ethnoart." *Annual Review of Anthropology* 8:267–307.

Silverman, Kaja

1983 *The Subject of Semiotics*. New York: Oxford University Press.

Speak, Dorothy

1988 "It's Inuit. Where Do You Put It?" *Inuit Art Quarterly* 3(3) Summer:4–7.

Stocking, George W. Jr. (ed.)

1985 *Objects and Others: Essays on Museums and Material Culture.* Madison: University of Wisconsin Press.

Sturrock, John

1979 "Introduction," in *Structuralism and Since: From Levi Strauss to Derrida*, John Sturrock (ed.). Toronto: Oxford University Press, 1–18.

Thompson, John B.

1984 *Studies in the Theory of Ideology.* Berkeley: University of California Press.

Thunder Bay Art Gallery,

1994 *Mandate Study: An Investigation of Issues Surrounding the Exhibition, Collection and Interpretation of Contemporary Art by First Nations Artists*, organized by Robert Houle and Carol Podedworny. Thunder Bay: Thunder Bay Art Gallery.

Townsend-Gault, Charlotte

1992 "Kinds of Knowing." In Nemiroff et al. (eds), 75–101.

1995 "Translation or Perversion: Showing First Nations Art in Canada." In Bennett and Blundell (eds.), 91–105.

Turner, Graeme

1990 *British Cultural Studies: An Introduction.* Boston: Unwin Hyman.

Valaskakis, Gail Guthrie

1993a "Postcards of My Past: The Indian as Artefact." In Blundell et al. (eds.), 155–70.

1993b "Parallel Voices: Indians and Others - Narratives of Cultural Struggle." Guest Editor's Introduction, *Canadian Journal of Communication* (special issue), 18(3).

1993c "Dance Me Inside: Pow Wow and Being 'Indian.'" *Fuse* (special issue on cultural appropriation) XVI(5-6) (Summer):39-44.

Vivelo, Frank Robert

1978 *Cultural Anthropology Handbook: A Basic Introduction.* New York: McGraw-Hill.

White, Hayden

1979 "Michael Foucault." In *Structuralism and Since: From Levi Strauss to Derrida*, John Sturrock (ed.). Toronto: Oxford University Press, 81-115.

Williams, Raymond

1973 "Base and Superstructure in Marxist Cultural Theory." *New Left Review* 82:3-16.

1977 *Marxism and Literature.* Oxford: Oxford University Press.

1981 *Culture.* Glasgow: Fontana.

Winner, Irene Portis

1978 Cultural Semiotics and Anthropology." In *The Sign: Semiotics Around the World*, R.W. Bailey, L. Matejka and P. Steiner (eds.). Ann Arbour: Michigan Slavic Publications, 335-63.

Wolff, Janet

1981 *The Social Production of Art.* London: Macmillan.

1983 *Aesthetics and the Sociology of Art.* London: George Allen and Unwin.

1990 *Feminine Sentences: Essays on Women and Culture.* Berkeley and Los Angeles: University of California Press.

Index

The Golden Dog Press

This volume was produced using the T_EX typesetting system, with Lucida Bright fonts.